# HANDTINTING
# PHOTOGRAPHS

# HANDTINTING
# PHOTOGRAPHS

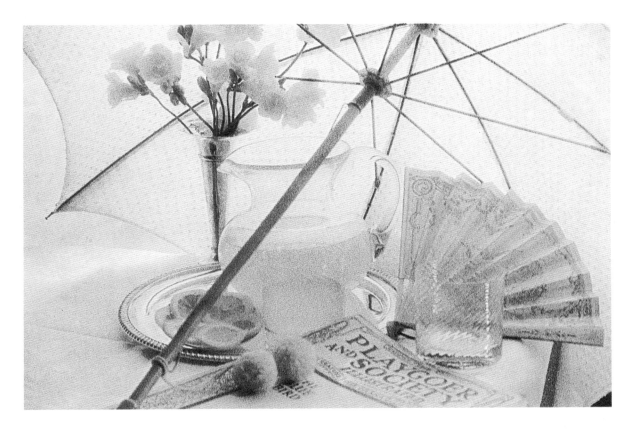

## materials, techniques and special effects
### JUDY MARTIN ■ ANNIE COLBECK

NORTH LIGHT BOOKS

Cincinnati, Ohio

First published in North America by
North Light Books
an imprint of F&W Publications
1507 Dana Avenue
Cincinnati
Ohio 45207

This book was designed and produced by
Amanuensis Books Limited
12 Station Road
Didcot
Oxfordshire OX11 7LL
England

Art director: Loraine Fergusson
General editor: Lynne Gregory
Production director: Kim Richardson
Picture research: Linda Proud and Lynne Gregory
Indexer: Susan Ramsay
Black-and-white photographs in Materials and Techniques:
Kim Sayer
Reproduction by Eclipse Litho Limited
Printed in Italy by STIGE Turin

Cover photograph: Desmond Burdon
Title page photograph: Alan Randall

# CONTENTS

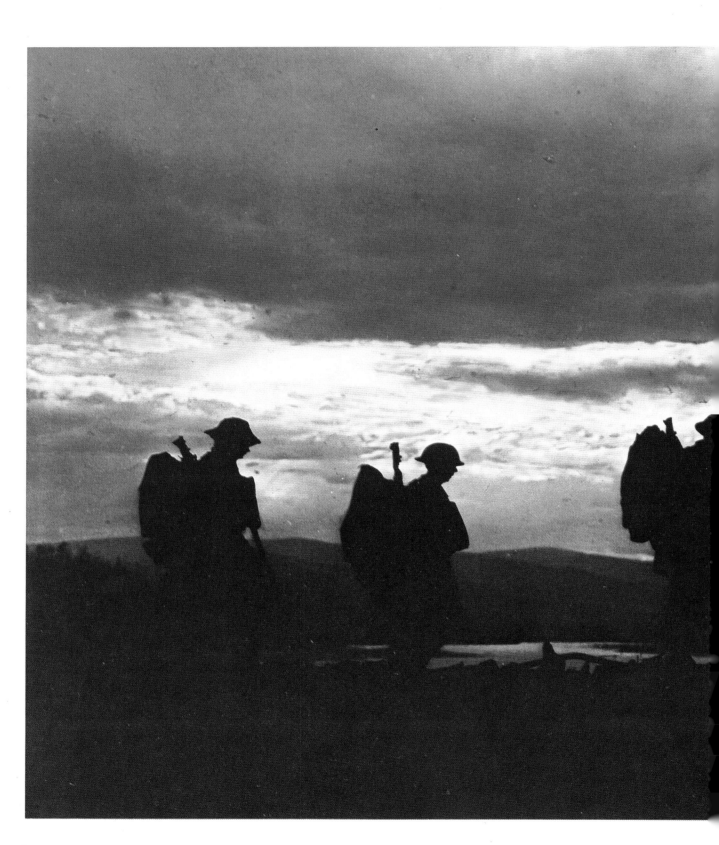

# History and Development

The desire for colour photographic images followed shortly after the advent of photography itself, when the magic of seeing a realistic image gave way to disappointment that the early photographic processes were unable to record colours. This was satisfied in the days before the development of a colour photographic process by the handtinting of black and white images. It was of course only a matter of time before colour photography was developed, but in the end it happened much later than expected. As a result, the art of handtinting can be seen on photographic images from the very earliest days of photography, and intermittently right up until the eighties where it has seen something of a revival.

**Burton Holmes: The Front, 1918**
One of the exquisitely handtinted glass transparencies from Burton Holmes' extensive collection. Pictures like this image from the First World War were shown in his travelogue lectures which were so popular in the early decades of this century.

# The daguerreotype

It could be said that no other invention captured the imagination of the public to the extent of the daguerreotype: the first practicable photographic process. It was patented by a Frenchman, Louis-Jacques-Mandé Daguerre, who refined the discoveries made by his partner Nicéphone Niépce, who in 1826 had taken the first known successful photograph. Daguerre was a theatrical designer and co-founder of the Diaroma, a popular show in which pictures were illuminated on a large canvas by reflected or transmitted light. Initially all Daguerre contributed to the partnership was an improved version of the camera obscura, the means by which images from outside were projected via a convex lens on to a flat screen. Two years after Niépce's death, however, Daguerre discovered the use of mercury vapour in the development of the image which drastically reduced the exposure time. He also found a way of fixing the image with a solution of salt such that although the complete process was founded to a very great extent on his partner's knowledge, Daguerrre renamed the process *Daguerreotypie*. His self-promotion skills were then put to work to get his idea taken up commercially. These met with failure until he secured the patronage of the astronomer François Arago, who was instrumental in the French government's acquisition of the invention. On 19 August 1839, the day regarded as the official birthday of photography, the development of the daguerreotype was announced to a vast, excited crowd by the French government. In return for the donation of this idea, Daguerre and Niépce's son received a considerable pension. However, this did not stop Daguerre taking out a patent for the process in England some five days before the announcement was made in Paris.

Daguerreotypes were made with a silvered copper plate sensitized by iodine vapour which was exposed through a camera to the chosen subject. The latent image was developed by heating a vapour of mercury which attached itself to those pieces of silver iodine affected by the light. The image was then fixed with hyposulphite of soda and rinsed with distilled water. The result was a finely detailed, positive picture with a delicate silvery surface which needed protecting under a cover glass to prevent it tarnishing through contact with air.

From August 1840 onwards experimenters in England, America and Austria further improved the process which lead to a better quality image

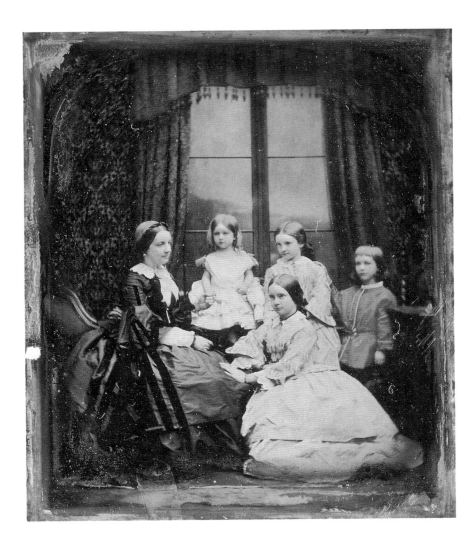

**Antoine Claudet: Family group,1855**
Claudet, a Frenchman, was one of the most distinguished daguerreotypists who practised in Britain. He was granted sole agency rights for the import and sale of French daguerreotypes and Daguerre's equipment. Claudet's images were superior to most daguerreotype-makers which was recognized by his election as a Fellow of the Royal Society.

and, most important to its role in portraiture, a reduced exposure time.

In an age of individualism and social change, the demand for portraits was phenomenal. An estimated ninety-five per cent of all daguerreotypes made were portraits. Before this time only the rich could afford pictures of themselves. There was a healthy trade among these circles in portraiture, served at the cheaper end of the market by the work of miniaturists. These painters believed their livelihood secure for the simple reason that the early daguerreotypes did not flatter the sitter, they were too true to life.

The first public studio was opened in England by Richard Beard. Beard was a coal-merchant and patent speculator, who engaged John Frederick Goddard, a science lecturer, to refine daguerreotype-making in the belief that photographic portraiture could be a commercial success. On 23 March

## Handtinting Photographs

1841 his idea was realized and he opened the first public studio on the roof of the Royal Polytechnic Institution in Regent Street, London. Typical of the hundreds of commercial studios which were set up after his, Beard's studio had a glass roof to let in as much light as possible. Mirrors were often used to reflect the sun on to the sitter's face and, in the early days when exposure could last as long as thirty minutes, heads were held still by the use of neck clamps, or the sitter's chin was characteristically poised on fingers. Little wonder then that there were disgruntled customers who complained most typically about the necessity of having to sit so still for so long with the sun painfully directed into their eyes.

The resulting daguerreotype was also often a cause of complaint. The miniature portraitists were right; common human vanity prevailed and many people expressed disatisfaction at the hard, mirror-like honesty of their image. No doubt the discomfort endured at the sitting was all too evident. The reproduction of colour as tones left a lot to be desired, with yellows and reds rendered dark and blues very pale. This generated complaints from a public used to the wide palette of realistic colours used in miniature portraits.

Over time, improvements in the chemicals used to develop the image lead to a reduced sitting time. Richard Beard charged a guinea a picture and the exposure time varied from three to five minutes in the winter, depending on the weather, to three seconds to three minutes in the summer. Daguerreotype-makers grew wise to the tricks of lighting and learnt to manipulate the light to highlight a sitter's good points and tone down less distinguished features. It was at this point that handtinting skills came into their own. For an additional fee the daguerreotype could be retouched to improve certain aspects of the image, give colour to a cheek and generally to beautify. In 1842 Beard, ever wary to whims of his clients, patented a method of colouring daguerreotypes. Ironically it was the miniature portrait painters, who found themselves increasingly out of work through the popularity of the daguerreotype, who found alternative employment in the handtinting of them. They used powder colours which were applied with great care with fine-haired brushes.

It took a trained artist's eye to handcolour a daguerreotype well. A particularly delicate touch was required as the daguerreotype's surface was not very stable and the mirror-like quality distracting and hard to work successfully.

The daguerreotype was most popular in the United States where an estimated three million were produced in one year alone. American daguerreotype-makers, unlike their European counterparts, produced panoramic images of landscapes on plates which were considerably larger, some as big as 24 x 20 inches (60 x 50 cms). Likewise the quality of their finish won the Americans universal praise.

After the initial years of enthusiasm, however, the disadvantages of the daguerreotype began to work against it. The process proved too costly and complicated for widespread use and the mirror-like image which made it difficult to see in certain lights gradually caused its popularity to wane.

## The calotype

Soon after the news about Daguerre's achievements were made public, the work of other scientists working in the field of photography came to light. W.H. Fox Talbot patented a process which he called the calotype on 8 February 1841. His process used paper as the medium. Good quality writing paper was soaked successively with solutions of silver nitrate and potassium iodide to form silver iodide, and then sensitized still further with gallic acid and silver nitrate. The image was developed by an application of gallo-nitrate of silver solution after which it was gently warmed over a fire. The negative was fixed with potassium bromide and then rinsed with water. The positive print was made, not developed, on a photogenic drawing paper. Although this technique produced pictures which lacked the brilliant clarity of a daguerreotye, it had the advantage that any number of positive prints could be made. In the early years of photography the daguerreotype was regarded as superior, but it is along these lines of negative/positive image making that modern photography is founded.

It is interesting to note that the first person to become a licensee of Talbot was a miniature painter, Henry Collen (the Queen's drawing master), who opened a studio in the autumn of 1841. He rather cunningly used the calotype system to quickly take small portraits which he used as a base for a drawing or painting. The product of the calotype process was a rather pleasing warm purple, brown image which made an attractive base for a handcoloured picture. As in daguerreotype portrait production, handtinters were employed by the makers of these prints to improve the quality and colour of the originals.

# Photography on glass

In 1851 the photographic invention which would eventually supplant all other methods, the wet collodion process, was announced by Frederick Scott Archer. Archer was an English sculptor who had mastered calotype-making to take pictures of sitters for reference. He developed a method in which a glass plate was given an even coating of collodion, then immediately sensitized in a bath of silver nitrate solution. Exposure had to happen while the plate was still moist and development followed on directly by the application of ferrous sulphate or pyrogallic acid. The process was harder to handle but exposure time was reduced considerably; small portraits (ambrotypes) could be taken in two to twenty seconds making it the fastest photographic process to date.

The ambrotype was backed with dark coloured velvet and bore a superficial resemblance to a daguerreotype. It could be handcoloured, again for a fee, by a handtinter using transparent oils or water-based paints. Ambrotypes provided a hungry public with portraits which were cheap enough to give away. From this technology a process for making contact prints was developed. A well-known Paris photographer, André-Andolphe Disideri, devised a way of taking eight shots via four lenses onto one plate, which reduced still further the cost of making prints. With this process the idea of the *carte-de-visite* was born. The craze for these portraits, reproduced on cards 2.25 x 3.5 inches (565 x 875 mms) began when Disideri used his new format to photograph Napoleon III who was reportedly on his way out of Paris to fight the Austrians. These cards launched the *carte-de-visité* overnight. An army of photographic studios sprang up in the 1850s and 60s to produce massive numbers of *carte-de-visité* portraits. Mayall and Company made sets of Queen Victoria and her family which sold in their hundred of thousands and made the company a fortune. Politicians, including the Prime Minister Gladstone and other celebrities had their pictures reproduced on these cards which were avidly collected and put in albums. Queen Victoria herself is said to have had 36 albums full of *carte-de-visité*.

These cards set the scene for the tremendous interest in sending picture postcards which followed early in the next century. Valentine and Sons Limited made their name and money in producing *carte-de-visité* portraits and were well placed to produce the massive number of postcards which made them an even greater fortune in years to come.

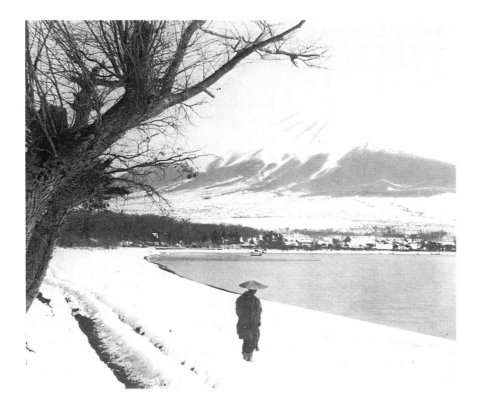

**Burton Holmes: Mount Fuji, 1892**
Holmes commissioned Japanese artists to handcolour this early glass transparency of the mountain in winter. It was probably among the first of his pictures to be handcoloured.

# Travel photography

The photographic image was developed in an age of discovery and curiosity about the world in which the camera fulfilled the role of travelling eye. The work of pioneer travel photographers was ideal for handtinting work as it helped to make their images remarkable, realistic colour impressions of the people and lands they had captured on camera.

The artistic skills of the Japanese must have made them particularly suited for handtinting as there are examples of Japanese handtinting in the work of a number of early travel photographers, including that of one of the first war photographers, Felice Beato (dubbed by *The Times* as the 'Knight of the Camera'). There was a good deal of interest in Japan which had only been opened to the west by the arrival of Commander Perry in 1853. The World Fairs of the 1860s created a fascination in the West for things Japanese. Beato was one of the first photographers to work there and together with his associate Charles Wirgham published a magazine for Britons in the Orient. *Japan Punch* featured Beato's studies of the Japanese people, the most beautiful of which were delicately tinted by hand.

## Handtinting Photographs

Burton Holmes was another travel photographer working between 1883, when he bought his first camera, right up until the 1950s. Holmes was a showman who coined the word 'travelogue' to describe his popular travelling lectures which filled theatres throughout the United States and received widespread critical acclaim. He used his photographic slides to illustrate tales of his travels and sought different, unusual ways to spice up his slides - this included handtinting them.

His early slides were made of glass. This process was developed by the Eastman company who patented a sensitized paper on which pictures could be taken, developed and cut into a single negative. This image was then transferred on to glass plates measuring 3.5 x 4.5 inches (9 x 11 cms) which were coated with collodion. It was glass slides like these that were exquisitely handtinted in Japan, one of the first countries he explored. A team of women artists were employed in this delicate work which involved the skilful application of watercolour paints to the actual glass plates. The picture of Mount Fuji (previous page) is one of those handtinted in Japan. Holmes enthused about its beauty and was much impressed by the subtlety of the colouring which he described as 'an illusion of violet mist'. There can be little doubt that he gave his handtinters a very thorough brief in their colouring of this slide.

In later years Holmes had his slides hand painted to very high standards by a team of handtinters in the United States who he himself trained. Much of the work is so fine that single-haired ermine brushes were used and in many cases the results are such that they look like the product of a modern colour film.

Holmes was a tireless traveller and his extensive collection of handtinted photographs are powerful observations of history. He rode the Trans-Siberian railway across Russia while they were still laying the track; visited Europe in the lead up to and during the First World War; covered the Russo-Japanese war and the building of the Panama Canal. In many ways he was a latter-day documentary maker.

His pictures of Europe in the halcyon days before the outbreak of the First World War are memorable. Paris made an impression on one of his earliest visits to Europe when he delighted in recognizing the sights from his extensive map and book reading on the city. The beautifully handtinted photograph of the ladies in a park (opposite) has a characteristically Parisian tree-lined background. Holmes also visited England and described

summer as a season of delight. He colourfully relates the fun of the Henley Regatta where 'nature-loving pleasure-seekers' enjoyed a very pleasant day out (overleaf).

These images are in contrast to his visit to Europe during the First World War in 1918. He travelled uncomfortably in convoy to Italy and from there made his way to the Front where he took the dramatic picture of soldiers silhouetted against a fiery red sky (pages 6-7). In many ways the world that Holmes knew and recorded was destroyed in the Second World War although he continued to travel and lecture till his death in 1958.

**Burton Holmes: Paris, 1907**
Holmes was charmed by Paris which he first visited at the turn of the century. This handtinted image beautifully captures a typical Parisian park scene.

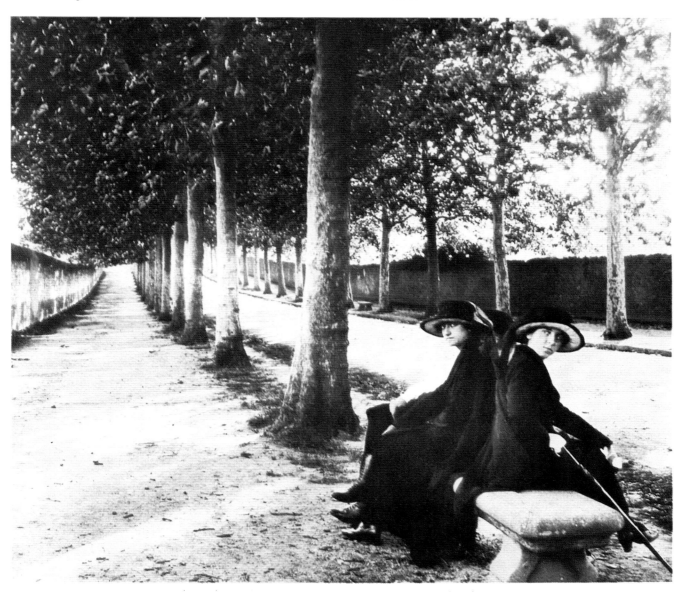

## Handtinting Photographs

**Burton Holmes: Henley Regatta, 1897**
This handtinted image is a vibrant evocation of a summer outing in Victorian England.

Another, more pioneering early photographer was Captain Noel. He was the official photographer of the Royal Geographical Society's expeditions to Everest in 1921, 1922 and 1924, from which Mallory and Irving never returned. As a keen, very able amateur photographer and with a childhood spent in the mountains of Switzerland, he was the ideal choice as Official Photographer. He was fascinated not only by Everest but by the people of Tibet; so much so that in 1913 he entered the country in disguise, while it was closed to westerners, and as a talented linguist was able to explore unchallenged.

Noel was influenced to handtint the glass slides that he made of the expedition by reading about certain American handcolouring practices. In fact, he later toured the United States on behalf of the Royal Geographical Society for a total of seven years, lecturing to the general public and using his slides to illustrate the expeditions - in true Burton Holmes' style.

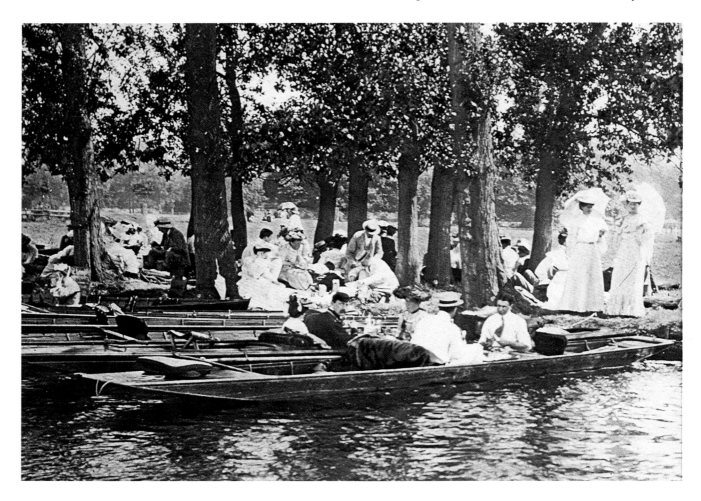

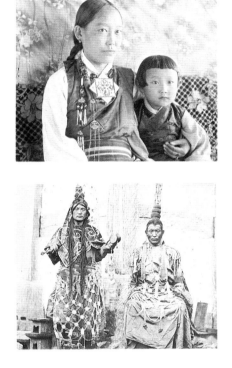

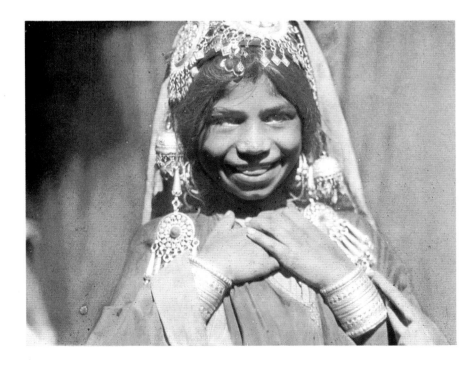

**Captain Noel: Pictures of Tibet**

Glass handtinted slides of the people and places encountered by Captain Noel as Official Photographer of the Royal Geographical Society's expeditions to the Everest in the twenties.

Travel photography was an arduous business in Captain Noel's days. There was a great deal of equipment to carry around which also had to be operated in situ.

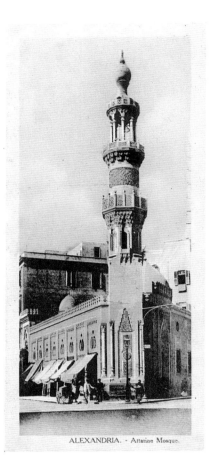

ALEXANDRIA. - Attarine Mosque.

# The golden age of postcards

Handtinted images came into the public domain in the golden age of postcards which spanned nearly two decades prior to the First World War. A coincidence of factors, not least the standardization of post mail sizes and the special halfpenny rate for the sending of a postcard, caused the Edwardians to send postcards for the slightest of reasons.

Many of the photographic images which appeared on these cards were coloured and, in the early days, the only way to do this was by hand. Francis Frith and Company produced an extensive collection of cards which consisted mainly of views from around the British Isles. These were sent to friends and relatives by the public who were enjoying a new pastime; the taking of annual seaside holidays. Interestingly, the founder of the company was a pioneer travel photographer whose photographs of the sites of Egypt caused a sensation when they were published in the 1850s. One of the company's most popular handtinted series of cards was a collection of views of the West Country, one of which is pictured here. Another prolific publisher of cards was Valentine and Sons Limited who owned and used printing works in Dundee and places as far afield as Melbourne and Cape Town. Prior to the First World War it employed over 600 people and used 50 printing machines. There were different departments for each of the processes involved: handtinting, glazing, plate making and so on. Over 40 artists were involved in the preparation of the cards.

A stencil process was also developed to help in the colouring of areas

**Above left**: An early handtinted postcard from Alexandria, Egypt.

**Right**: A card from the Romantic series produced by Joseph Welch and Sons of Mile End, Portsmouth.

Who is it?          My Honeysuckle.          JWS 2479

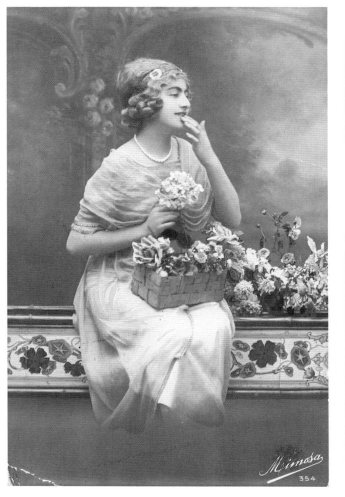

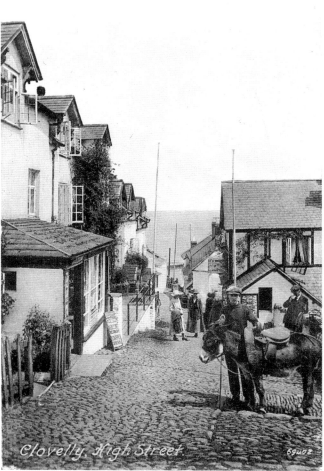

of the cards, but by and large the process was still very labour intensive. Francis Frith and Company used a large team of women workers to handtint their cards by stencil process. Master stencils were made for each of the different colours on a postcard from which cardboard stencils were made. A team would be issued with stencils and ink rollers for a particular colour and they would set to work on the base printed card. When the colour had been handtinted on all the cards, they went to the next team for an application of a different colour until the postcard was completely coloured.

A step on from this was colour work in which colour was added to black and white images at the printing stage. The simplest process of this kind involved filling in a black outline with colour to make relief blocks for letterpress printing. This was used extensively in the publishing of American newspapers and magazines up until the 1940s. Alternatively the key could

**Above left**: Many postcards were produced featuring beautiful women of the day, images which were handtinted for added effect .

**Above right**: An original handtinted Francis Frith and Company card. It is one of the very popular postcards from their series of West Country scenes - one of the company's earliest series of postcards.

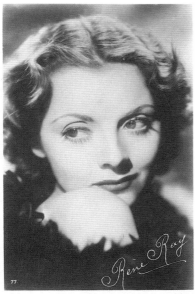

RENÈ RAY     GAUMONT-BRITISH STAR

be added to a zinc plate, and a coloured image built up by the addition of successive zinc plates, a different one for each colour. This is the essence of the autochrome process which was used to print many of the later postcards of the boom. The success of these processes, however, like the handtinting of images, depended entirely on artistic skills, this time of the etchers involved in the making of the colour-selective plates.

## The thirties

This decade saw a revival of interest in the collecting of portrait cards in the same vein as the *carte-de-visité* cards produced for widespread public consumption in the Victorian age. This time, however, the collectable portraits were not the politicians or the royal family but the film stars of

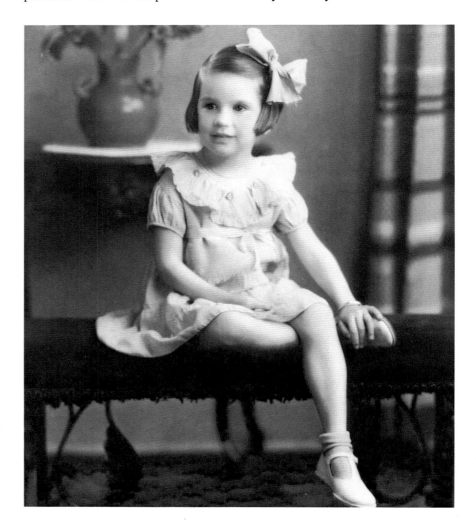

**Above**: One of the handtinted cards produced under the Gaumont studio title of one of their British stars, Renè Ray. Her signature is printed in the corner of her portrait.

**Right**: A charming handtinted portrait commissioned of a professional photographer in the United States in the thirties.

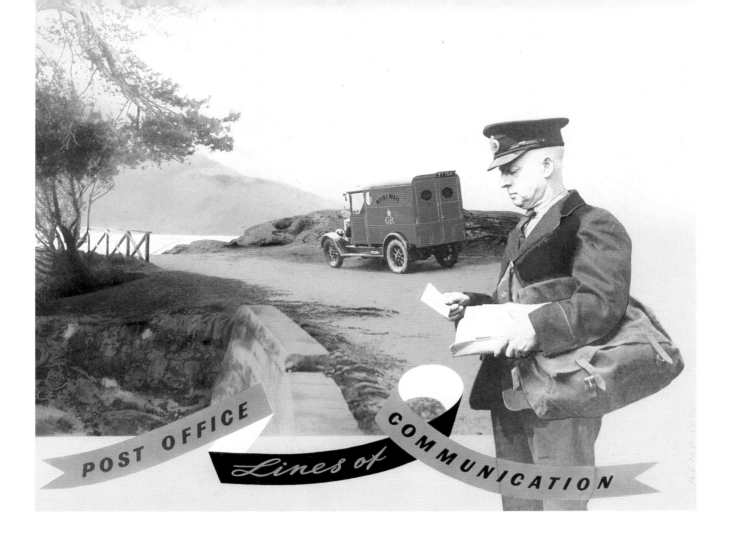

Hollywood. The glossy, promotional pictures produced by the Hollywood studios were lovingly handtinted and reproduced to postcard size under their own studio imprint. It is curious to note that these coloured images were produced in a time before colour film and some of the so-called Hollywood greats, including Greta Garbo, were only seen in colour on cards like these.

**F.H.K. Henrion:**
**Post Office Savings poster**
Commissioned in 1938, this poster must be one of the first handtinted, photographic advertisements of its kind.

## Handtinting in vogue

Handtinting lost its rather functional role as a means of providing colour and became more of an art form in the late thirties and during the forties. F.H.K. Henrion is one of the founding fathers of modern design. He experimented and achieved the most dramatic effects through the use of handtinted, superimposed photographic images in the days before colour photography. It is these distinctive images, pioneered by Henrion, which are emulated by designers today because they embody the fifties style currently so popular.

Born in 1914, Henrion has been working professionally since he arrived in England in 1936, having trained in Paris in textile and graphic

## Handtinting Photographs

**F.H.K Henrion: 'Eat Greens'**
Commissioned by the Ministry of Food
during the Second World War.

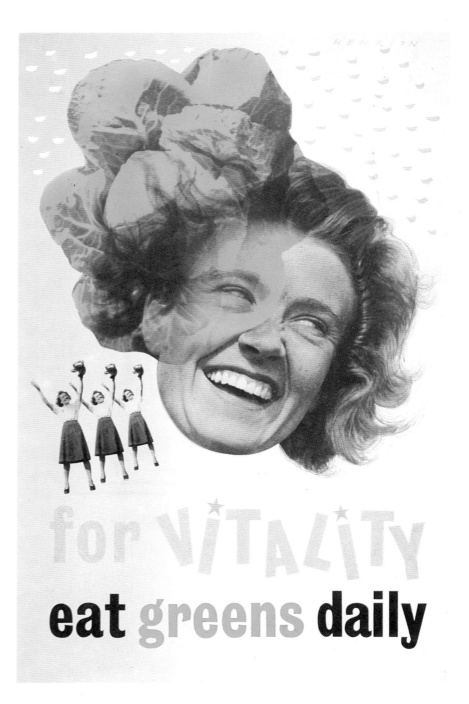

for VITALITY
**eat** greens **daily**

design. Two years after his arrival he produced one of the first handtinted
photographic posters in existence. In 1938 he handcoloured a poster
commissioned by the Post Office. The background he handtinted on a print
made up to a workable size of approximately 10 x 8 inches (25 x 20 cms).
Upon this base image the black-and-white photographic image of the

postman, photographed separately, was superimposed. This simple, uncluttered image is typical of Henrion's direct, eye-catching style.

During the war Henrion worked for the government and produced a poster promoting healthy eating for the Ministry of Food. 'Eat greens daily' had a modern, jokey look which did not fall into the trap of patronizing the public, which clearly was a danger given the message. Again the apparent simplicity of the image is the result of sophisticated technical work in which three photographic images have been skilfully superimposed on a backdrop. Henrion in this poster, as with all his work, took charge of every aspect of the image: the styling of the photograph, the painted backdrop and the typography.

From 1943 to 1944, Henrion produced a series of advertisements

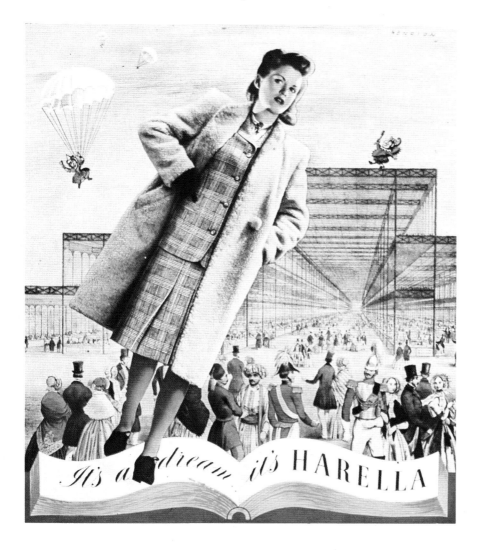

**F.H.K. Henrion: Harella advertisement**
This image was part of a series produced for Harella, the textile manufacturer, between 1943 and 1944.

# Handtinting Photographs

**F.H.K Henrion: Harper's Bazaar cover**
One of the original Henrion cover designs of this fashion magazine. Henrion was commissioned to design their covers for a total of four years.

for Harella, a large textile manufacturer. Henrion created the complete concept. He painted the exotic, busy backdrop, which has the quality of an animated film still, commissioned the fashion shot and superimposed the image at a jaunty, coquettish angle. The typographic message is typically succinct and direct, in deliberate contrast to the richness and slightly surreal visual elements; all of which make the advertisement particularly memorable.

The originality and new ground broken by Henrion did not go unnoticed at the time and he was commissioned to design the covers of the fashion magazine *Harper's Bazaar* over the next four years. The cover

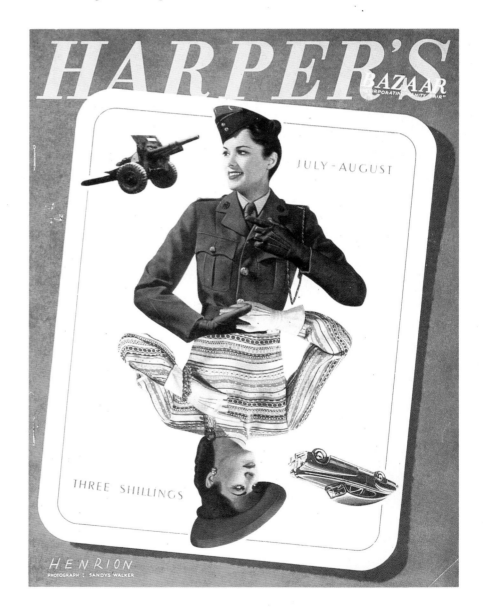

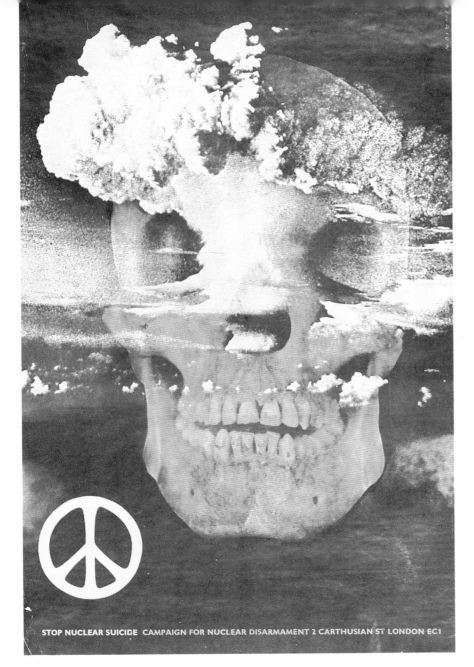

STOP NUCLEAR SUICIDE CAMPAIGN FOR NUCLEAR DISARMAMENT 2 CARTHUSIAN ST LONDON EC1

opposite again demonstrates Henrion's imaginative use of handtinted images and his appealing, quirky sense of humour. After the war, Henrion was the leading designer of the two much acclaimed pavilions in the Festival of Britain in 1950. Since then he has expanded his design achievements over the widest possible range and is noted as the person who developed the concept of corporate identity for companies. Above is the famous poster which he created in the sixties for the Campaign for Nuclear Disarmament. From the fifties up until this time he, like many other designers, was exploring the possibility of high fidelity colour film, yet for this harrowing poster he chose to handcolour the image. Henrion considers the ability to conceive and work a handtinted image a skill like any other in the designer's repertoire.

**F.H.K. Henrion: CND poster**
Commissioned by the organization in the sixties, this is an enduring picture of the anticipated horror of nuclear war.

### Ford advertisement

This advertisement has a handtinted backdrop which works to suggest the individuality of its owner. The contrasting high fidelity colour of the car does not detract from the image, but makes the car look smart and desirable.

As a lecturer Henrion is in wide demand throughout the world, has held a series of posts in design colleges and organizations and is a leading light in a number of prestigious international design organizations.

## Handtinting in the eighties

With the progress made in the development of colour film and, indeed, with colour printing, the delicate art of handtinting was out of vogue for a couple of decades. It was used only occasionally in the fashion shots of the sixties and seventies as photographers and magazine editors searched for original ways to present the latest fashion trends.

For many years processed colour was synonymous with quality: the glossier the image the greater the value accorded it. It is, however, the very fidelity, convenience and cheapness of modern colour film that has revived the art of the handtinter today. Handtinting is unique in its ability to impart an old-fashioned feel to modern subjects. The photographs in this book go further and prove that in combination with skilful darkroom techniques,

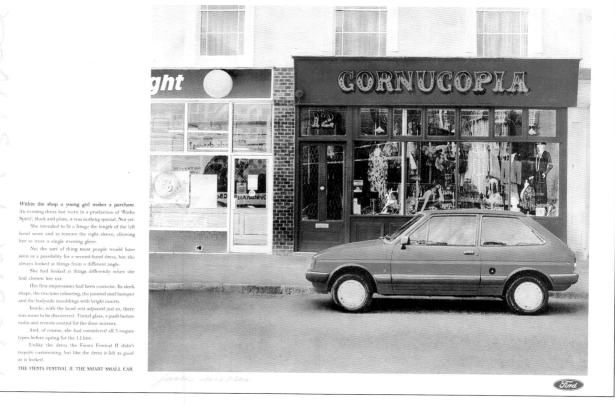

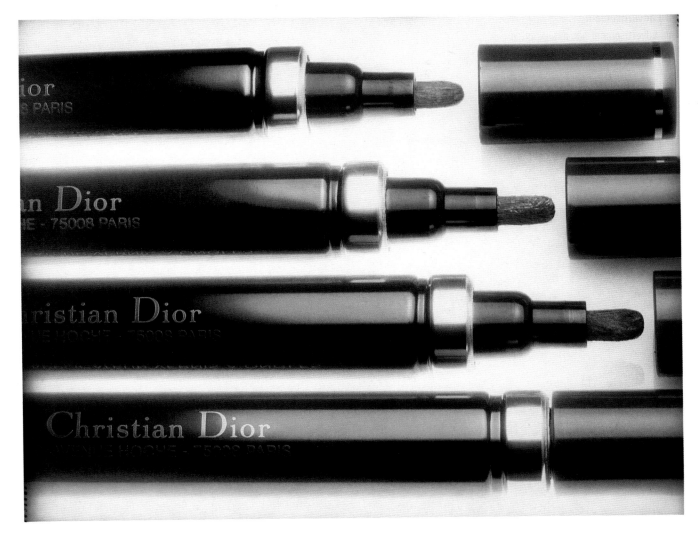

handtinting has evolved to produce very new contemporary images, many of which have been used extensively in the media.

Advertising is a focal point of the media because its success depends on the way in which it interprets trends from other sources, like the movies or television, to make a product contemporary and appealing. The automobile market sells its product by creating an image for it which suggests prestige and individuality. For years the high budgets of automobile manufacturers have been spent by advertising companies in perfecting glossy, beautiful colour images of the product. More recently to create a stylish and different package their advertisers have used handtinted images. In the promotion of the Ford Fiesta (opposite), the hantinted backdrop suggests the individuality of the car-owner while the true colouration of the car itself emphasizes its

**Clint Eley: Christian Dior advertisement**
Eley experimented by handcolouring this commercial shot to see if artificial colour could improve on the genuine colouring. He felt that in many ways it created a more interesting image. For a description of the methods Eley used on this image, see page 111.

# Handtinting Photographs

## Berol 'Scribbles' advertisement

The makers of this award-winning advertisement looked to old-fashioned and time-consuming methods in the handtinting of each of the film frames, rather than use of computer colouring systems now available. They believed that handcolouring would give a more organic feel to the addition of colour to film. For a more detailed description of the methods used to create this ad, see page 154.

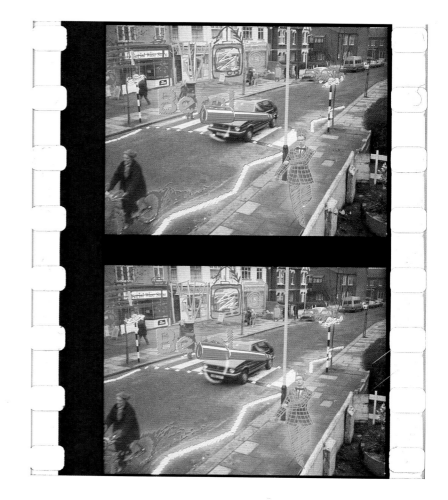

modernity, and its reliability as a piece of up-to-the-minute technology.

Some photographers have found possibilities in the handtinting of black-and-white images that have improved on a colour photograph of the same subject. In the Christian Dior advertisement (previous page), Clint Eley has enhanced the richness of the lipstick tips by the skilful addition of more than one colour. The cosmetic casings are also enriched by the subtle addition of colour to give the product an aura of luxury and opulence.

Handtinted effects are also being used on videos and film. The music world, ever keen to cut a different image, has experimented with different mediums in the promotion of bands and has made the pop video very much a creation of the eighties. Giblets, for example, combined the sophistry of film with the more organic effects possible by handtinting each frame of the film to reflect the energy of Johnny Clegg and his band, shown on page 153. A similar technique was used to produce the award-winning advertisement

made for Berol of which there are a few clips opposite as well as on page 155. Handtinters were used to hand work each frame to a very specific brief to create an animated sequence over filmed action which is both memorable and light-hearted. It is interesting to note that computerized colouring systems have also been developed to create similar effects faster, but they are generally felt not to have the authentic charm of genuine handtinting.

Many photographers have explored handtinting techniques for their own pleasure and achieved some exciting effects. Far from its origins as a rather secondary art as an accessory to photography, handtinting can now be regarded as an art form in itself.

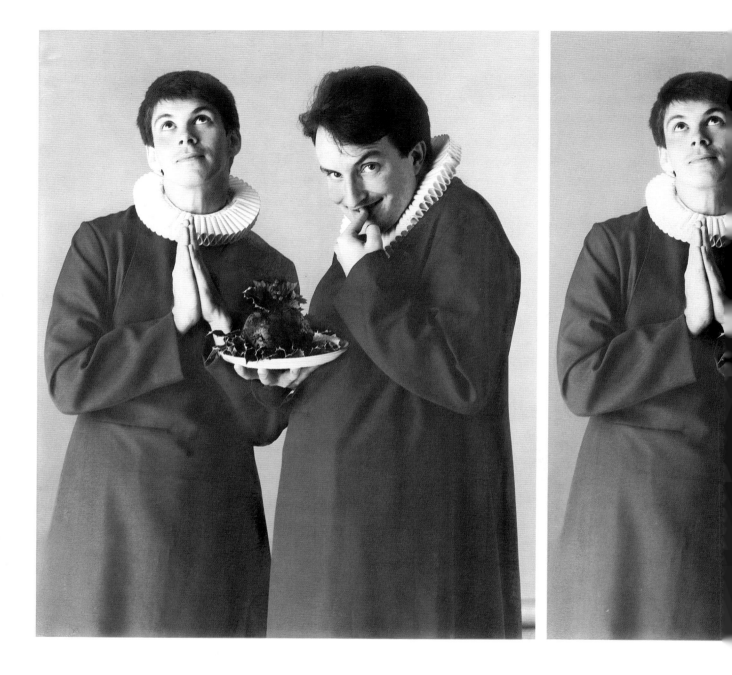

# Preparation

Choosing a suitable print for handtinting is critical in the creation of a successful handtinted image. A good tonal range is needed in the image which should also be interesting compositionally. If you have the facilities to create a print, there are a range of darkroom processes which can be experimented with to provide an interesting tonal base to the print.

**Justin Pumfrey**

Pumfrey's first version of this shot of the comedy duo, Kit and the Widow (right) was developed as a black-and-white print before handtinting with oils. The second was sepia-toned to warm-up the overall tone of the print before, again, handtinting (left). The sepia-toned image was regarded as the more successful.

# Selecting a print

An ideal print for handtinting is one with a full range of tonal values and very few solid black areas. The reason is simple enough: colour applied on dark areas does not show in the same way as colour applied to lighter areas. It should, of course, also be a successful photograph which fires your imagination to make it worthy of handcolouring treatment. In fact, it should be stressed that the special effect of colouring a print can only very occasionally do anything substantial to enliven or improve upon the essential composition of a photograph.

When selecting a well-composed image to use, look for a sense of balance and harmony in the composition with the subject of the photograph in pleasing relation to the subordinate objects. The viewer's eye should be drawn to the central feature and then take in the lesser features before being led back to the subject. This is achieved in a variety of ways. The central subject can be framed physically, like Carl Hulme's picture of a man leaning in a doorway, page 118. Harmony in composition can also be created by light through the placing of a light object against a dark background or vice versa, as in Alan Randall's *Lemons* on page 105. It can be balanced against another object of equal weight, or a sense of perspective can help lead the viewer's eye into the composition, whether created in a linear fashion, by a receding fence for example, or by the use of space. Mark Hamilton's image of children against a treeless backdrop on page 120 is given depth and drama by the telegraph poles disappearing into the background.

The paper on which the photograph is printed is also critical. Paper which is matte or semi-matte is easiest to use as it better absorbs applied colour, whether oil- or water-based, and dries quicker. Resin-coated glossy paper makes handtinting almost impossible; oil paints are not absorbed, watercolours sit on the surface and refuse to dry, while pencils simply scratch the surface. A number of photographers, however, successfully use oils on fibre-coated glossy paper, though the oil colours can take up to a week to dry.

The best print size on which to work is approximately 10 inches (25 cms) wide by 8 inches (20 cms) deep. This is usually a large enough size for colour work, though many photographers/handtinters prefer to work on much bigger prints.

# Creating a print

If you have the facilities to develop your own print, you can organize the composition of the photographic image and go further and use a variety of darkroom processes to add special effects to it. The basic techniques are outlined below, but you will only discover the possible effects through experimentation with your materials. It is a good idea to make darkroom notes on the type of paper and dilutions of chemicals you use, the length of time involved in each process and the darkroom conditions. Only by keeping notes like these will you be able to reproduce an effect you like again. For a visual record of your findings, add to these notes any test strips that you make together with any unsuccessful prints.

Before you start work, however, be under no illusion that you will get the effect you want first time round. Darkroom techniques like bleaching and toning require a lot of practise, skill and patience. For this reason make more than one print for handtinting work.

**Choice of film**

Black-and-white film is categorized into fast, medium and slow film according to its sensitivity to light. Fast film when exposed has the effect of increasing the size of the silver hadide crystals to create a grainy image with a resolution that is not crisp. This grainy effect can be accentuated by enlargement and gives the print an interesting background for handtinting.

Infra-red film is favoured by photographers because of its relative unpredictability which can create images with interesting special effects. Infra-red film is sensitive not only to light but to imperceptible infra-red radiation. Many handtinters overexpose infra-red film to take advantage of the grainy effect created in this way.

**Use of filters**

Filters can be used to manipulate the final result of film. The use of a red filter, for example, will allow only infrared radiation to pass through with the result that these areas appear lightest in tone, though it tends to make areas like the sky, for example, darker. Both green and yellow filters allow different segments of light through, and this affects the highlighted areas of the negative. Experiment for yourself to discover the effects possible with filters of different colours and degrees.

**Papers**

Your choice of photographic paper will affect the tonal values achieved in a print, and it comes in a wide variety of surfaces, base tones and weights. The paper surfaces available are glossy, semi-matte and matte. Glossy surfaces tend to have contrast and hold more detail, semi-matte surfaces have a more subtle tone separation and matte surfaces are dull and flat which actually work well with high-contrast negatives.

Papers have different base tones or colour temperatures too: warm, neutral and cold. These temperatures effect the atmosphere of a print and should be selected accordingly. Likewise the higher the grade of paper (grade four is the highest) the more condensed the tonal separation will be, that is the more limited the range of tones. If too low a paper grade is used, tones will appear flat and it will be hard to get a true black. Harder paper also exaggerates the grainy effect of the print.

Lith paper, which is also used by some handtinters, gives prints a high level of contrast. The matte or semi-matte paper that is ideal for prints to be made for handcolouring is manufactured in a range of grades but unfortunately is not standardized.

# Darkroom processes

**Burning in and dodging**

This is a standard darkroom technique which is used either to correct the exposure of film or can be used creatively to darken or lighten areas. By the strategic placing of a piece of black card or a hand over the developing print, an area can be held back and kept lighter - this is called dodging. Other areas of the print can be made darker, providing greater contrast by greater exposure to light - this effect is known as burning in. Techniques like this require a great deal of experimentation and skill, so be prepared to use several sheets of paper before you are satisfied with the finished print.

**Bleaching**

Bleaching is used to lighten dark areas or reduce the overall tonal quality of a print. Bleaching solution can be made by mixing up potassium ferricyanide with potassium bromide dissolved with water, or bought ready-made to add to water. The more dilute the solution, the slower the bleaching process and the greater control you have over the level of

bleaching. There is an option to totally bleach out a print but a more interesting effect can be had from partially bleaching. A subtle, straw-yellow colour results from removing the print and putting it in water at a critical point just before full bleaching.

Bleach can be applied to specific areas of a print after the print has been thoroughly dampened. It is advisable to use a rubber-based masking solution to mask out the areas you do not want effected by the bleach. Use a cotton swab or clean brush to apply the bleach to smaller areas, a sponge can be used to cover larger areas (blotting to remove excess fluid) and fix and rinse the print thoroughly. For overall bleaching of the print, soak in a bath of this solution and watch and remove when the desired amount of tone has been eaten away.

# Toning

Toning is a chemical process by which the metallic silver areas on a print are coloured and areas from which the silver has been completely removed, like highlights, remain white. There are a variety of ready-to-use toners available, it is advisable, however, to check the instructions or consult the supplier before you use a toner on a print to check that the paper and toner are compatible. In some circumstances the only way you will find out is through experimentation, so be prepared for early mistakes. Toning will have different effects on different paper and should be done in a moderate, artificial light.

### Selenium toning

Selenium toner, like all toners, has a different effect on different papers. In general terms, it gives a reddish-brown hue to warm-tone papers and makes cold-tone papers colder. It is meant to give a print permanence but also has colouring properties which can be used to give a base tone to prints.

Selenium toning starts work on the dark areas and moves onto the highlights, therefore a print that is slightly flat can be given greater contrast through selenium toning. Follow the instructions given with the toner, or if you want a more subtle change in the colour, further dilute the solution. Mix the chemicals to one part of water for fast toning or to ten parts of water for gradual toning.

---

**Selenium toning**
Method
1. Mix up the selenium toner using a tray especially set aside for the purpose.

2. Justin Pumfrey finds the best method is to thoroughly wash the print with a cleaning agent before putting it in the toner. Others prefer not to wash the print but tone it fresh from the fixer as they find that drops of water create stains on the toned print.

3. The type of paper and the degree of tonal change you want determines the length of time the print stays in the toner solution. Keep a careful eye on the print and remove when the desired effect is achieved.

4. Rinse thoroughly as per usual.

## Handtinting Photographs

### Selenium-toned print

Justin Pumfrey is a photographer/
handtinter whose favoured handtinting
medium is oil on fibre-based glossy
paper. For this selenium toned print
Pumfrey used Agfa Record Rapid paper.

Pumfrey chose to selenium tone this
print because he wanted to enhance the
warmth of the image. The Franciscan
monk is pictured in rather austere
surroundings and yet his face is that of a
friendly, warm character. As selenium
works from the darkest areas first, the
monk's habit is coloured in its natural
brown colour and the overall tone of the
print is warmed up.

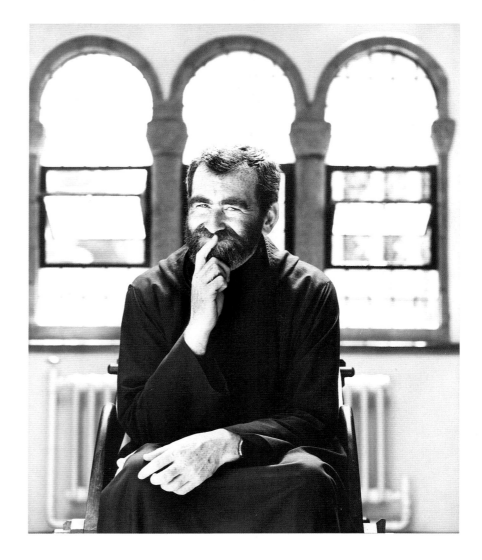

### Sepia toning

Many handtinters favour this toning effect because it gives the print a warm-
red base on which it is easier to work up colour than a stark black and white
image. The chemicals for sepia toning come ready-mixed and simply need
to be diluted with water. There are now a wide range of different sepia mixes
available on the market with which to experiment, from yellow-brown
hues through to copper-red.

Sepia toning is called a two-bath process because the print is always
bleached before toning. Both bleaching and sepia toning starts working
from the highlighted areas to the darker areas, the opposite to selenium
toning. Therefore to preserve dark areas as black and the mid-grey areas in

A print prior to sepia toning. See overleaf for the effect of the toning.

**Sepia toning**
Method
1. A print should be well-fixed and washed before bleaching, then bleached prior to toning.

2. Mix up the sepia toning solution, following the instructions that come with the chemicals.
   The degree of tonal change is largely determined by the degree of bleaching and the type of paper. Toning redevelops the print in the base colour of the toner.

3. Rinse thoroughly as usual.

a print you should only partially tone with sepia. A useful tip when making a print for sepia toning is to make it a quarter stop darker then usual. This is because the sepia process tends to reduce the print by a quarter stop and burn out the highlights to make the print slightly paler. By printing a quarter stop darker, or selectively bleaching, this effect is overridden.

### Sepia-toned print

Justin Pumfrey sepia toned this landscape to bring out the sandy colours of the beach. The print was partially bleached beforehand, which accentuated the highlights and bleakness of the stretch of sand. It was then only partially toned in sepia to keep the print's original areas of black and some of the grey mid-tones. This enforces the coldness and vague sense of danger of this sandy, seaside scene. For this image Pumfrey used Ilford Gallery paper because it is a neutral paper which adds contrast and does not effect the colour.

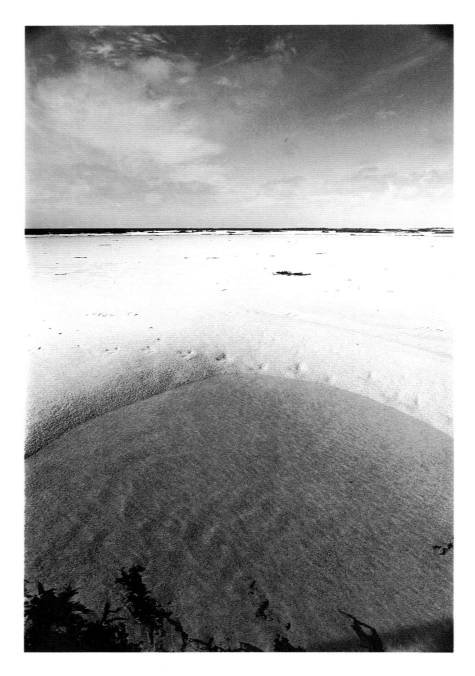

# Iron-blue toning

This creates a brilliant blue colour, though it is also the least permanent of the toning processes. The level of toning depends on the original print, with the toner giving intense colour to the areas which are darkest. It works well when used in combination with bleaching or when applied to a slightly

underexposed print. The method for iron-blue toning is the same as the method outlined for sepia toning.

It is the effect of putting an iron-blue toned print in fixer that reduces the level of blue toning. The colour can be intensified, however, by re-developing the print in developing solution to clean the print of all colour then re-toning in the iron-blue toner solution.

The highlights in an iron-blue toned print do tend to creaminess. To compensate for this, the print can be soaked in a solution of one part acetic acid to thirty parts water which will help it hold the whiteness in the highlights.

The type of paper used affects the tonal range of the blues. A softer range of blues can be had on soft grade paper, but be warned there is no guarantee that the toner and the paper will be compatible, so experiment.

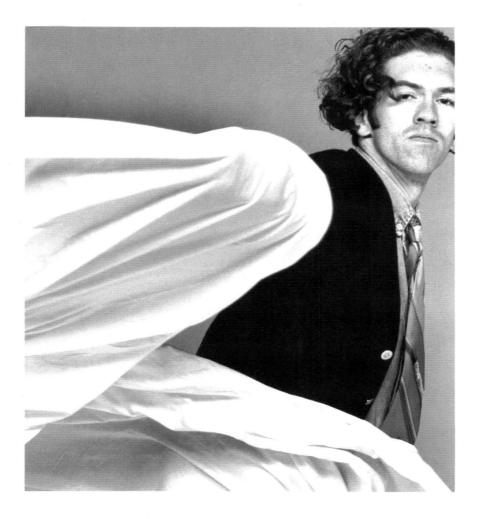

**Iron-blue-toned print**
This print appears hard and uncompromising as a result of its iron-blue toning. Justin Pumfrey used a grade 2 paper to get a full range of blues, but only partially toned it to preserve some of the black areas and give the image a hard, sharp outline.

For a harder blue toning, Pumfrey recommends the use of grade 4 paper.

**Split-toned print**

Justin Pumfrey wanted the face in this print to appear white in contrast to the dark areas of his hair. By bleaching first then partially toning in sepia, the lightness of the face was achieved. For further interest the print was washed then immersed in the iron-blue toner. The pleasant green/blue colouration was achieved by only partially toning in the blue toner, so there is only the slightest suggestion of the colour in the mid-tone areas of the print.

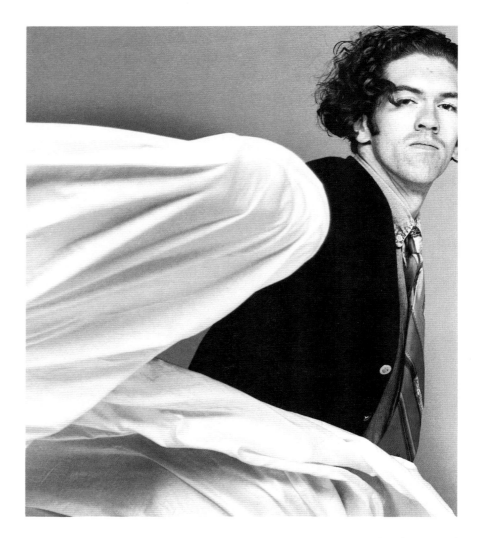

Also, be very cautious when washing the print after toning. If it is washed for longer than three minutes, the blue toner may wash away.

## Split toning

Split toning works to give a print a three-dimensional feel as a whole range of tones are created. This can be achieved by changing the temperature in the toning bath. Use the same procedure as for selenium toning, but experiment by leaving the print in for a longer time at a higher temperature.

Split toning can be achieved by partially toning a print in two of the different toning solutions. This can bring about a variety of effects, but it is wise to do this only when you can confidently predict the results from each individual process.

## Reticulation

The crazed patterning on prints (like the cover picture for this book) is called reticulation and although often brought about through bad processing, can be achieved as an effect in itself. It gives an aged effect to a print and is especially effective with images where there are large expanses of areas, like wasteland or sea for example.

All that you need to do is vary the temperature between the developer and stop bath by more than 5°F, the rest of the procedure is standard. Do remember that once this effect is achieved it is irreversible.

## Preparing the print for work

To assist the absorption and even distribution of the colour on the print, soak the print in warm water some fifteen to twenty minutes before you wish to start work on it. Use a wetting agent, like ox gall liquid or even a drop of washing-up liquid diluted in water to help the paper stay wet for longer. Remove and blot to remove surplus water. Set on a flat, solid working surface. To keep the print still for more detailed handtinting work, attach its edges to the surface with strips of masking tape.

# Materials and Techniques

Many people when presented with a black-and-white print for handtinting throw caution to the wind and indulge in colour which, more often than not, is bright and bears only a superficial similarity to the subject's natural colouring. Obviously there are no set rules and experimentation is to be encouraged, but it is interesting to note that a more interesting effect is often achieved through rendering a print in naturalistic colours. The almost-real effect works better than a colour scheme which deliberately ignores and subverts the known natural colours of a subject. Irrespective of the medium chosen to handtint a print, all of which are discussed later in this chapter, there are principles which are common to them all. These principles if understood and applied can avert disappointing early attempts at handtinting, and lay the foundation for more sophisticated experimentation.

**Mark Hamilton**
This print has a range of tones and textures which make it ideal for handtinting. Hamilton made the print on lith paper to create this high contrast, grainy image. See the handtinted version on page 119.

## Tone

An ability to work out the tonal values within a print is essential to good colouring. The density of colour used to handtint one area as compared to another should make tonal sense and create a feeling of depth and three-dimensional space. There is a danger that the use of colour can blind the handtinter to the tones in a print. It is wise to experiment first with a limited palette of colours; after all, it is easier to create a darker blue to contrast with a lighter blue than mix another colour which has an equivalent tonal value.

The white or lighter areas of a print are vital to the cohesion of the image, so do not be tempted to handtint them simply because colour is best seen against a lighter background. Before starting work on a print, take time to make sense of the play of light and dark areas contained in it. This will also help you in the process of planning your handtinting as it is always best to tint the lightest areas on the print first, gradually working up to the handcolouring of its darkest area.

## Colour

It is an accepted theory of art that some colours give a feeling of warmth while others seem cool. There are scientific reasons for this but on a basic level we associate warm colours like red with fire and others like blue with the cold waters of the sea. Colour temperatures have a part to play in the mood and space and dimension of a coloured image.

When handtinting a photograph try not to mix too many cool and warm colours in that one piece of work. A predominance of cool blue tones with just a touch of warm colour or vice versa generally makes for successful images. A sensation of depth can also be helped by using warm colours in the foreground and keeping colder colours towards the back.

Be aware of the colours which exist in shadows and have the effect of bringing to life the colour of the object they surround. Shadows are not simply a darker version of a colour, they contain the complementary (ie opposite) colours of an object. The shadow of a red flower, like a poppy, for example, will have touches of blue. Likewise in an image containing many objects crowded together, the colours of one object will be reflected in and picked up by the objects surrounding it.

# Choosing your handtinting medium

You will only find out which medium you prefer through experimentation, but it wise not to invest too much in materials too soon. It is possible with both water-based paints and oil colours to buy just a few tubes of colour or a bottle of ink or dye to get a feel for the techniques involved in their use and the effects they can achieve.

The cruder materials, like inks, designer's gouache and felt-tip pens are in many ways harder to use successfully. This is because they have a concentrated colour which is less forgiving to use.

Water-based photographic dyes should be used cautiously and the colour built up slowly to create a subtle colouring which is integral to the print. Oils are also flexible as colour can be toned down by rubbing them into the print surface, but be careful as the effect can be over done and the photograph can end up looking more like an oil painting than a print. This is because oils, like blendable pencils, create a layer which is additional to the print surface which can make it look painterly.

Look through the Gallery section of handtinted prints to get a feel for the way certain subjects have been treated. It may be more constructive to look at the effects possible with different mediums, and then put this knowledge to use when deciding how to handcolour a print.

# How much to handtint

Very often handtinting is used to call attention to one particular area of the photograph. Make sure the splash of colour is visually balanced by the background setting and the tones contained within it and does not look like a colour shape out of context. In general, muted, neutral colours are found in the background of photographic images and positive, darker colour in the foreground.

Try and avoid sharp outlines, even in the foreground when highlighting an area, as this gives an air of unreality to the tinting. There simply are not hard outlines in nature and it will have the effect of disassociating the image outlined with the rest of the photograph.

Half of the skill in handtinting is knowing when to stop working on a print. The colourwork should enhance the drama of the image, not clutter or confuse it. Do not tint too much of the naturally occurring light areas;

handtint the less than light areas, the grey mid-tones, to build up contrast. This skill comes with experience, so learn from mistakes and build up your handcolouring slowly and thoughtfully. It pays to have ready a scheme for working an image before you apply the first wash.

Another effect that can be achieved with handtinting is the addition of another dimension. A photographic image can be completely coloured in a monotone in a dye-bath which is both quicker and easier than chemical toning. This is usually most successful on a dramatic image with particularly good tonal contrast such as Sue Lanzon's skyscrapers on page 79, or on a print which could benefit from having an old-fashioned, nostalgic 'sepia' look such as Helen Z's shop window on page 82.

# Application

### Airbrushing

An airbrush is ideal for working up detail. Bob Carlos Clarke used the technique on his picture *The Dark Sisters* on page 138. It produces an even jet of paint or dye by means of a compressor or a can of compressed air. For the handtinting of photographs, an airbrush with a double-action mechanism is best as it gives greater control of the flow of air and therefore paint through the brush, making it ideal for detailed work. Using an airbrush requires a certain amount of skill and experience, but once mastered gives a professional, clean finish to the application of colour such as Jack Miller's treatment of the Fiesta on page 146. However, it does represent a considerable investment. A cheaper alternative is the Letraset air marker which applies colour, like an airbrush, by using a jet of compressed air to force colour out of a felt-tip marker.

Whatever type of airbrush you use, before trying a mixed colour on a print, do a few tests on a scrap of paper to check the density of the colour and to check that the instrument is working correctly. Build up colours gradually in a series of layers (it is best not to let the layers dry in between) to ensure that you do not overcolour the image. Remember to rinse the airbrush thoroughly before applying a different colour. Airbrushing should only be carried out in conjunction with masking.

### Masking

Masking is the means of isolating an area of a print for special treatment,

Before using clear, adhesive, low-tack, soft-peel masking film on a print, make sure it is firmly attached to the work surface with masking tape. It is wise to cover the entire print with the film then carefully cut away with a scalpel the areas which you want to work. Apply the colour to the print and peel away the masking film to reveal a clean edge to the coloured area.

with an airbrush for example. There are a variety of materials which can be used to do this, one of the most popular being a clear, adhesive low-tack, soft-peel masking film. This film is stuck to the print and will not damage the print surface or pick up colour already applied, providing the surface is dry. Mark Hamilton uses masking extensively (see pages 87, 88 and 119). Use a sheet of film large enough to cover the print and carefully cut and remove areas of film with a scalpel to reveal the portions of the print on which you wish to work. The trick is to apply just enough force to cut the film but not to damage the print.

Liquid masking fluid is applied with a brush on to the areas of the print which you want to mask. Work on the print only when the masking fluid has set, and peel it away when the paint or dye has dried. Both of these methods of masking give a hard edge to handtinting work, unlike the use of a moveable mask. A moveable mask like a piece of drawing paper, card or clear acetate placed strategically on the print can be used to mask out areas and give a softer edge to the finish.

# Handtinting Photographs

**From the top:**

**Airbrush**: The marker airbrush illustrated is cheaper than a commercial airbrush but just as effective for close work.

**Brushes**: For oil painting you can use a hog-hair brush, like the one pictured, which is a good jobbing brush, or a nylon-bristled brush which, though not so hard-wearing, is better for delicate work and is more versatile. They come in sizes from 1 to 14, 14 being the largest; a standard size 7 or 8 is best for handtinting work. The best quality watercolour brushes are red sable, but sable blends are available which combine sable hair with cheaper squirrel or ox hair. Pure ox hair brushes are coarse and do not form a good point while pure squirrel hair brushes are too soft and hard to control. Synthetic brushes are inexpensive but quickly lose their point. Use round headed, large-bristled brushes (sizes 8 to 12 are the largest) to lay down washes of colour over large areas and fine-haired brushes for detailed work, the smallest are designated 0, or 00 or 000.

**Crayons:** Crayons, wedge-shaped or pin sharp add texture as well as colour.

**Cotton wool swabs**: For applying colour in smaller areas, especially oils. Homemade swabs can be created using cotton wool bandaging material wound around a matchstick end. This way a swab can be made to a desired size.

**Blotting paper or paper towelling**: This is invaluable for blotting the surface of the print to remove surplus water or paint during the handcolouring process.

**Cotton wool balls**: Invaluable for lifting surplus water from washes and in the application of colour, especially oils.

**Sponge**: A small natural or cosmetic sponge has many uses. It can be used to swab down the print with water to keep it damp for working, and is ideal for highlighting areas by lifting out the colour or removing colour when handtinting goes wrong. It can also be used to apply colour and create a stippled effect.

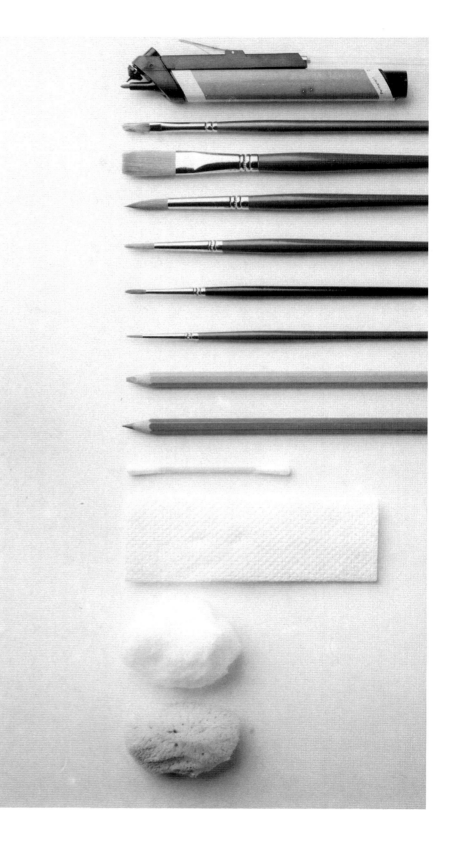

**Dye-baths**

Soaking a print in a dye-bath is a quicker way of achieving the effect of the darkroom process of toning. You can use cold-water fabric dyes or a saturated photographic dye in which to soak the print for 15 minutes or more, depending on the level of toning you want for your print. This will create an overall toning much more quickly than adding colour by hand with a wash and sponge. A dye-bath of sepia-coloured dye solution can help to give a print an old-fashioned, time-worn look.

**Palettes**

A mixing well for water-based dyes and paints is a good investment. You can use saucers, plastic tubs or bottle tops but they must be white to let you see the true colour of the dye as you mix it.

A white dinner plate can be used on which to put small quantities of water-based or oil colour in readiness for lifting and mixing. Commercial palettes of plastic or glass are available, as are pads of disposable sheets.

**Miscellaneous items**

You will need at least one jam jar to hold water for washing brushes as well as a pot of clean water to dilute paints or dyes, and a magnifying glass is often useful for very fine close work on a print.

A hairdryer can be used to quicken the drying process of water-based colour applications. Do not use the hairdryer too close to the print or you may damage the print's surface, and do not waste time trying to artificially dry oil colours.

# Food dyes

Many handtinters have achieved a professional finish by using the most basic of colouring methods. Food dyes and substances like coffee are very effective and have the advantage of being relatively inexpensive.

**Method**

Prepare the print by cleaning it with water to get rid of greasy marks and dampening it down with water perhaps mixed with a wetting agent ready

## Handtinting Photographs

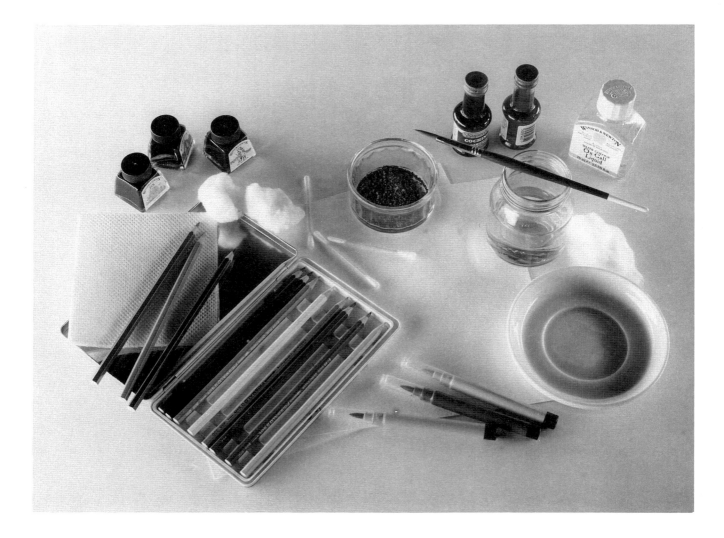

**Miscellaneous materials**
Clockwise from top left: inks, instant coffee granules, food dyes, ox gall liquid (wetting agent), clean water and a paint brush, diluted ink in a mixing saucer, felt-tip pens, artist's crayons with paper towelling, cotton wool balls, cotton wool swabs and blotting paper.

for the application of colour. Mix up the colour washes by heavily diluting drops of food dye with water. Mix these colours in white saucers or white plastic bottle tops or tubs. Warm reds are more intense than cooler tones like blues and greens and should be diluted accordingly with more water to tone them down.

It is best to layer on washes of colour to build up the density of the colour, rather than adding too concentrated a colour early on in the process. This will ensure a more subtle and controlled build up of colour. Use cotton wool balls or swabs to add the colour and blot the print after each wash to remove surplus water. Apply the washes successively and as rapidly but carefully as possible, while the layers are still wet.

If you do not like the effect of the colouring, food dyes, unlike

photographic dyes, can be washed out by immersing the print in water for five minutes or so. It can also be lifted off with a damp sponge or damp cotton wool balls.

Detail can be added to the print using a fine brush or a matchstick covered with a piece of cotton. Use slightly more concentrated colours than those used in the washes, but err on the cautious and be wary of using too saturated a colour. It is much easier to add colour than to take it away.

A sepia-type tone can be added to a print by the use of instant coffee granules. Undiluted coffee granules crushed onto the print surface with a cotton wool ball is effective, quick and easy. Experiment with other household products for colouring properties, but be wary of their stability.

## Felt-tip pens

Felt-tip pens and marker pens can be used to dramatic effect on prints. Rather than the controlled use of washes to build up colour, the use of felt-tip pens requires a bold approach. Vibrant dashes of colour can add energy to an image, rather like the effect of cleverly applied graffiti. Experiment with water or turpentine to break down the hard edge of felt-tip pen lines.

## Inks

Artist's inks may be mixed with other inks and greatly diluted with tap or distilled water to handcolour prints. Inks have a great staining capacity and should always be heavily diluted before they are applied to a print's surface. Build up density of colour by the addition of washes of these ink solutions but be careful: inks are not a flexible medium.

## Crayons

Blendable artist's crayons (like Caran d'Ache) applied to a print surface can be broken down, or blended, into less pure colour by the addition of water. These crayons tend to be rather more effective when several different colours are used than a single pure colour. Sue Lanzon uses crayons very successfully in her New York skylines on pages 80 and 81.

# Handtinting Photographs

## Method

Prepare the print by cleaning off grease marks and setting it on a good solid worktop. The conventional way of working with pencils is to build up colour in layers on a dry print. This is known as overlaying and is composed of fine parallel lines hatched closely together. Subsequent layers of other colours are thinly overlaid to create a colour which is shimmery with more life than a flat colour. This technique also enables the artist to create a graded colour effect.

A more densely coloured, grainy effect is achieved by handtinters when they optically mix colours by cross-hatching with long or short crayon strokes. Complementary colours can be used to great effect with cross-hatching, creating a lively area of colour rather like the effect of the weaving of wools of different colours to create tweed. It is always best when cross-hatching to lay the lightest colour first. Another way of adding colour is by building it up in dots. It is important that colour is not applied on the print too thickly so that the light areas of the print are still noticeable and act as an additional colour.

The effects possible by the addition of water to crayon lines require a little practise. Test the reaction of different crayons to water on a piece of scrap paper first as some pigments tend to be stronger than others. Select a brush of an appropriate size for the area to be worked, the larger the area the greater the size. Load it with water and set to work on the crayon coloured area you wish to blend first.

Experiment with the effects of different brushstrokes. The colour deposited by the pencils will be broken down to a greater extent by heavier brushwork, whereas lighter brushwork will preserve the painterly effect of the drawn lines. The quantity of water used will also make a difference to the finish. Flooding the print's surface with water will create a less controlled, uneven blending of colour. Less water will break down the colour to a lesser extent and will produce a watercolour effect. Further pencil effects can be added after the print has dried, some five to fifteen minutes when left to dry naturally, less time if you use a hairdryer. The general rule applies: save the strongest colour for the foreground detail and fade colours into the background.

You can work by wetting the paper before you start work and apply the coloured pencils to the dampened areas. Use a wetting agent to keep the surface damp for a good working period. Commercially produced wetting

agent should be mixed to the proportion of five to six drops to 100 mls (four fluid ounces) of water, or use washing-up liquid mixed to approximately the same proportions. The less water on the surface, the better the control of the crayon line which becomes very unpredictable, and blotchy with too much water. Pencil marks can be washed out, but the effect of the crayon marking may leave a slight indentation on the print surface.

The overall effect of crayon colouring prints is to give it a grainy, slightly surreal look with the pencil colour providing a less integrated finish than is possible with watercolours or oils.

# Photographic (retouching) dyes

Watercolouring has a special delicacy and luminosity which makes it ideal for colouring photographs. Photographic or retouching dyes are completely translucent and when mixed together or diluted with water can produce any required tint or strength of colour. A small amount of dye is diluted with water so that when the water evaporates there is a thin layer of colour through which the base photograph shines through. The applied colour actually stains the gelatine layer of the print making it difficult to remove. For this reason it is best to build up colour gradually through several applications, rather than attempting to match colour and density in one go.

For inspiration, look at the virtuoso work of Clint Eley and his still life of fruit on pages 102-103, the work of Helen Z and that of many other photographers/handtinters featured in the gallery who favour this water-based medium.

**Mixing colours**

Experiment by using a limited palette of colours, combining first warm and cool versions of the three primary colours, red, blue and yellow. When you are familiar with the basic palette of primary colours and the possibility of their secondary colours, work with additional dyes to create neutral colours. Warm brown and black can be modified by the addition of yellow, green and reds in various quantities and dilutions to give a range of brown and grey tones. Mix colours in a watercolour mixing tray, white saucers or white plastic bottle tops or tubs. Make sure that your mixing water is clean to get a true result from your mixing and beware of using too many colours as this will make nothing more interesting than a nondescript muddy colour.

# Handtinting Photographs

**Dyes and watercolour materials**
Clockwise from top left: set of photographic dyes, ox gall liquid (wetting agent), cotton wool ball, cosmetic sponge, paper towelling, handmade cotton swabs wound around used matches, tubes of designer's gouache, blotting paper, paintbrushes and watercolour mixing tray.

## Method

Colour is easiest to apply when the print is soaked with water containing a little wetting agent. Wetting agents can also be added to colour mixes which keeps the wash wetter for longer and helps when attempting to cover a large area, though it can make the wash a little harder to control. Blot to remove excess water and lay the print on a clean glass or plastic working surface. Keep damp while working by gently swabbing the print with a wet sponge

Apply colour on the largest and palest areas of the print first. Use a small sponge, airbrush, dense wide brush or a cotton wool ball. Mix up a large quantity of well-diluted colour as it is hard to achieve an identical wash later. Test all the colours mixed on a scrap of paper before committing

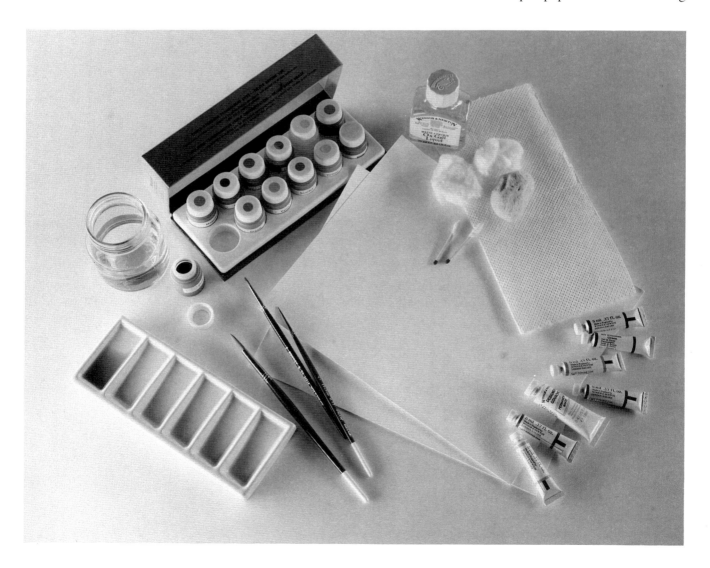

it to the photographic print. The wash is best applied onto a slightly angled print to encourage the wash to settle in the direction you are working. Brush in horizontal bands working from the top of the area to the bottom. Reload the brush or sponge and pick up the stream of concentrated colour at the bottom of the band of wash, and make another horizontal band. Continue in this fashion until the bottom of the area is reached. Squeeze out the brush or sponge and pass it across the bottom band of wash to pick up any excess water. This method ensures an even wash. Repeat with more of the same wash mix to increase the density of colour on the print, or mix other washes of cool or warm complementary colours to add form to the image. These layers of wash are best applied while the print is still slightly damp.

To work smaller areas nearer the foreground, less saturated colours are required. Experiment with a fine, smaller-haired brush to find the hand position in which you feel most comfortable and have the greatest degree of control. For fine strokes use just the tip of the brush and position your fingers on the ferrule. You may find it helps to rest your hand on the photograph, but you would be well-advised to lay a clean piece of paper under your hand to protect the photograph's surface. If the detail is to be applied on top of a base colour, make sure that the wash is thoroughly dry. If a wet, loaded brush or area of colour comes into contact with another area of colour which is still damp, there will be a certain amount of bleeding of colour between the two. To avoid this make sure that areas of the print surrounding the area to be worked is dry or blotted. Colour is also best applied to small areas in a series of layers until the desired density is achieved as this allows less room for error.

If white is required to help brighten an area of a print or a colour, use colour from a tube of white watercolour paint or diluted poster paint.

Colour can be lifted in part with a sponge from areas which are still damp, but be warned: it is not possible to completely remove the colour of dyes from a print.

# Gouache

Water-based opaque paints (designer's gouache) can also be used for handtinting. Unlike photographic dyes they do not blend into the surface of the print, but create another surface. For this reason you need to apply colour in an accurate, controlled fashion as it is not a forgiving medium.

**Mixing colours**

Arrange a small amount of the gouache you intend to use on a palette like a white dinner plate or commercially produced one. Using an artist's mixing tray, lift a dab of colour on the end of a brush and add mixing water to it to create the required hue. Before applying the colour to the print, test its consistency against the back of your hand. If it produces a smooth line with ease then it is ready to apply, if it requires pressure then the paint is too thick and needs further watering down and if the paint beads on your skin it is too thin. Do not test it on a piece of blotting or towelling paper as these substances will drain it of some of its water.

**Method**

Dampen the print with water and set down on a flat worktop. Working the largest areas first, and from light to dark, apply the gouache mixes in the same way as the photographic dyes. However, the heaviness of these paints will limit the number of thin washes that can be applied successfully so you will have to aim for accuracy early on in your colour mixes.

## Oils

There are specially produced oil paints for the handtinting of photographs, although artist's oils available in tubes work just as well. Oils are durable, less likely to change over time and have a good opacity and covering quality. The technique for application varies considerably, as you would expect, from the water-based dyes. Look at the work of James Walker and Adriene Veninger to get a feel for the different ways in which oil can be used on prints.

**Mixing colours**

Arrange small quantities of colour on a mixing palette or on a large white dinner plate from which smaller quantities can be lifted on a brush for mixing. Palettes made from disposable sheets are useful as you can label in pencil your different oil colours, plastic palettes also offer this facility. Pure colours can be blended on the surface of the photograph itself, or for more control can be mixed beforehand. Remember that warmer colours like red, orange and yellow tend to be stronger while cooler blue colours are more

retiring. A solution called Artist's Painting Medium solution which is composed of linseed oil and petroleum distillate can be used to thin oil colours. If this is not available use artist's distilled turpentine, but in small quantities. The addition of Artist's Painting Medium solution or turpentine to warmer colours will give them a lighter tone and the greater the quantity of solution used, the lighter the colour will become. Thinning solution is best applied with a cotton wool swab, or cotton wool ball. Pick up a quantity of colour on a brush, cotton wool swab or whatever you are using to apply the colour and dab it with the swab loaded with your thinner. This provides a degree of control over the amount of thinner added to the colour and does not pollute your paint or thinner. If you find this method too fiddley, pick

**Oil-based materials**

Clockwise from top left: disposable palette, cotton wool swabs, paper towelling, cotton wool, Artist's Painting Medium, distilled turpentine, soft brushes and oil brushes, set of oil colour tubes.

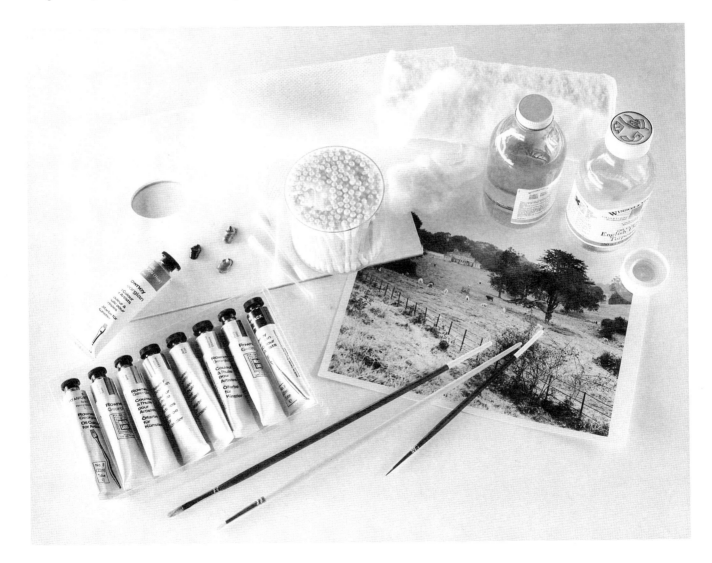

up a little thinning solution on a brush and use it directly on your paint to mix a less saturated colour.

To load the brush with just the right amount of paint, wipe the brush bristles on a piece of towel to remove the excess. Oil paint is very concentrated and it will avoid a lot of time rubbing paint into the print surface to get a less concentrated colour if you have a fail-safe method for applying it.

## Method

The beauty of using oils is that the intensity of colour can largely be controlled by the extent to which the colour is rubbed into the print surface - and if everything goes terribly wrong, a thirty-minute soaking in a tray of water should wash the oil away completely.

There is no need to wet the print before working on it. Start by colouring the larger areas of the print first. With the chosen colour picked up on a cotton wool ball, apply the colour on to the print in a gentle, circular motion. To rub in the colour and tone it down, smooth over the area with a clean cotton wool ball until the colouring is evenly distributed and the desired tone is achieved. It is good practice to add each colour, mixed or pure, working from the lightest areas to the dark areas to avoid a preponderance of dark colour which is difficult to remove without cleaning the print and starting afresh. Smaller quantities of colour can be rubbed into this base pigment while it is still damp to obtain an organic feel, but this requires a delicate touch.

The detail of smaller areas can be added with a brush or with a cotton wool swab. Oils do not dry off completely for 24 hours, but their texture is such that with careful application, two areas of different coloured paint sitting alongside each other will not blur and a reasonably crisp line can be achieved. If you have applied a background colour on to which you want to add additional colour, it may be worth waiting for 24 hours if you do not want the colours to blend.

To ensure that you do not overload your brush or swab with too much paint, wipe the end on a piece of paper towel to reduce the quantity and also to check the density and tone of the colour you are about to apply.

Some handtinters like to use water-based colour to finish the fine detail of the print colouring as they find dyes easier to control in the small quantities needed than oils. However, there is no reason why with a steady

hand and a bit of practise you should not be able to manipulate oil paint into the small details on the print. Experiment to discover which medium you prefer.

Oil painting is very different, both in the application of colour and in the result. Whereas colour is built up gradually using water-based colour and the light areas of the print show through, with oils, light areas are interpreted by an application of light colour which tends to produce a print which has a rather more painterly finish.

# Gallery

**Desmond Burdon**
This picture was created to hang in a
fictitious art gallery for an advertising
shot. The Quest cosmetic bottle was
photographed in black and white and then
made into a number of transparencies
which were each handtinted separately.

Hantinted photography was once an art of necessity, the only way to apply colour to photographic images before colour film processing became a widely available and relatively inexpensive option. After that, and until quite recently, processed colour became a hallmark of prestige and modernity. In the media, advertising and book publishing it signalled quality products; the glossier the presentation, the more the value that could be assigned.

The craft of handtinting went into abeyance, brought out only occasionally as a way of conveying a sense of nostalgia in a photographic image, frequently as a reference to Victorian style or fading personal memories. Within the past few years, however, a number of artists have, for various reasons, started to reinvestigate the possibilities of applied colour in photographic work. More recently still, handtinted pictures have gained a fashionable prestige of their own, and the work of handtinters is once again much in demand.

Many of the contemporary artists represented in this book have perfected their techniques and visual style over several years primarily for personal satisfaction, and now can reap the benefits of increasing commercial and public interest in their work. All practise both photography and handtinting: for some, the colour work is only one aspect of the skills they can offer to a prospective client; for others, handtinting is their primary and highly specialized skill; others still approach it on a non-commercial basis, more in a fine art than a commercial design context. They have different reasons for investigating these particular techniques and between them come up with varied interpretations of the handcoloured photograph, but there is also a considerable degree of common ground.

A fascination with the particular visual qualities of old-fashioned handtinted prints has sometimes been the starting point for an interest in the techniques of handcolouring, but this only serves to open up the broader implications. To be involved with handtinting, you need a definite appreciation of the photographic image, otherwise it would make more sense simply to become a painter. In fact, artists such as Housk Randall and Adriene Veninger come from a background of fine art training and have, for various reasons, moved into the medium of photography, bringing their painterly skills to a new style of image. Housk Randall took up photography as a hobby and extended his work to handcolouring because, as he said, it allowed him to contribute to forming the image with 'hands as well as with eye and brain'.

## Handtinting Photographs

Another interesting reason for working in this way was explained by Juliette Soester, who believes that our eyes have become too accustomed to full-colour photographs such that we no longer take in much of the detail. Handtinting allows the photographer/handtinter to focus certain elements in a picture, to accentuate individual features or create atmosphere, or simply to decorate the surface. Also, as Soester said, it is sometimes required to subdue the image. Helen Z uses colour to 'give information about the main points of the picture', and Sue Lanzon spoke of the pleasure of being able 'to make your own colours'. Selectivity and control are crucial aspects of the handtinter's working methods.

Although colour film processing has acquired more versatility in recent years, Alan Randall, who specializes in photography for advertising, is sure that the combination of monochrome prints and handtinting techniques still enables him to produce a unique image quality unobtainable with colour film. Helen Z also pointed out that colour treatments no longer tend inevitably to refer to an old-fashioned style; the techniques lend themselves equally to contemporary images or nostalgic moods, as is certainly demonstrated in the range of examples illustrated in the following pages.

A unique aspect of handtinting is the permanence of the photographic record combined with the possibility of continuous change, in the same image, through the use of different handtinting techniques and colour interpretations. If you hold the picture negative, you can print any number of black-and-whites and treat each one with different colour moods; or you can return to the same image after some time has passed and approach it from a fresh viewpoint with the benefit of new experiences and skills. The image can evolve, as Clint Eley remarked, 'however you see it at the time'.

This is part of the pleasure of visual imagery, but always to look for a literal (or literary) meaning is often to overlook the disciplines of art and design which are uniquely combined in handtinted photographs. Shots are composed in terms of line and mass, tone and texture, as well as for their strictly descriptive qualities. The photographer selects film and printing materials to produce the required quality of image - from needle-sharp definition to grainy atmospherics. Colours applied to the print provide formal qualities of balance, harmony or even deliberately jarring notes, whatever is required, which the artist judges by eye and develops by technical skill. The rich surface qualities of painting and drawing media can be superimposed on the photographic base, or colour can be flooded into

part or all of the composition using special chemicals and darkroom techniques.

One thing which must be kept firmly in mind, especially for anyone making first investigations into the possibilities of handtinting, is that the photograph is the starting point which sets the general standard of the final image. As Helen Z put it, 'to get an excellent result, you need an excellent beginning'. Gerry Reilly emphasized the same point in a different way, explaining his purpose as having a good picture to start with and then working to make it better. He warns that handtinting cannot be used as a cover-up technique, as the painting will tend to have the effect of highlighting poor picture quality.

The pictures in the following pages demonstrate what can be done with toners, paints or dyes, and crayons. They cover a range of images and photographic subjects, some of which were taken expressly for handtinting, while others were selected for colour treatment sometimes months or years after they were taken. They include studio compositions and outdoor views, serial pictures and one-off shots seizing the chance moment. Certain of the pictures were commissioned for specific purposes and the photographer/ handtinter was given a restricted brief to work to; in other examples, there was more freedom to put personal interpretation into a commissioned work; still other images were created purely for personal pleasure or experiment. Not all are the product of years of experience. Several artists have submitted examples of early work which encouraged them to further exploration of the medium. All demonstrate how handtinting can help to put a highly individual stamp on products of the 'impersonal' eye of the camera.

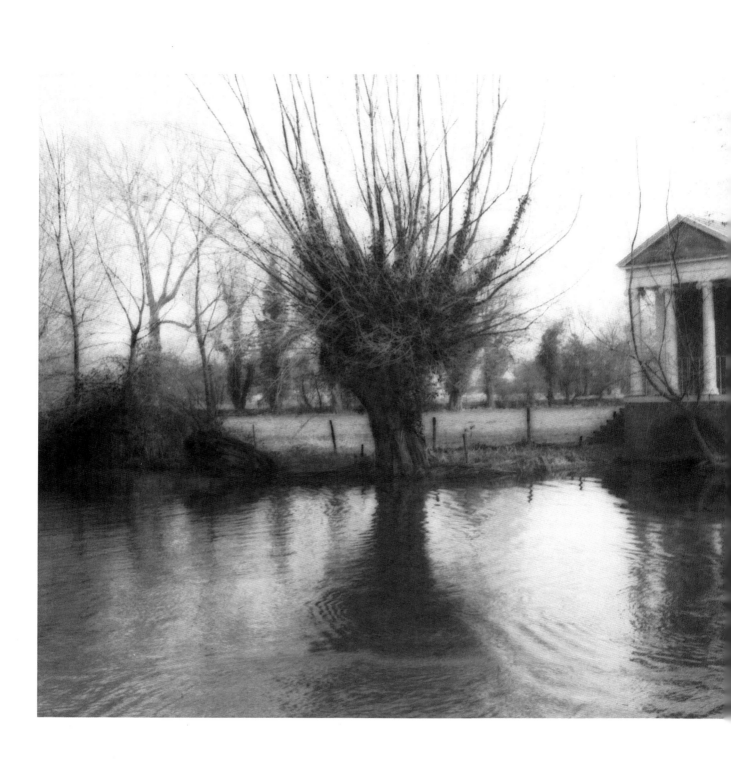

# Landscapes

Landscape is a theme of universal fascination and has become well established as one of the principal subjects of modern art, providing an opportunity to investigate natural light and colour on both an intimate and a grand scale. The painter's preoccupation with light in landscape, so effectively celebrated by the Impressionists, has been naturally extended by the work of photographers in ways appropriate to their medium: some have painterly preoccupations, others refine their viewpoint through the precision and clarity of photographic means.

Handtinted photographs provide a unique opportunity to apply the skills of a thoughtful colourist to the tonal analysis objectively rendered by the camera. But, as we know, the 'realism' of photography is often itself an illusion, and the process of handcolouring is also used to enhance the strange moods and transient visual impressions which can be captured photographically. Colouring by hand allows the artist to intervene in the landscape while preserving its characteristic atmosphere. It also allows for different interpretations  after the event - the black-and-white image remains a constant record, but can be continually re-presented to the viewer through the use of colouring mediums.

**James Walker: Dedham Vale**
Oil paints thinned to a transparent consistency result in soft colouring.

# The silent landscape

A recurring theme in landscape imagery is the uninhabited landscape, a place of stillness which offers plenty of scope for the imagination and many different interpretations. Often, although there is no actual human presence within the picture, there is the suggestion of a personal dimension in some aspect of the view. This is the case in several of the pictures shown here: the human element is, for example, represented architecturally by the folly in James Walker's view of the river in Dedham Vale (previous page), and by the wooden bridge over a waterlily pool described by Juliette Soester (above), both of which are timeless and slightly mysterious images.

There is a notable ancestry to James Walker's picture. Dedham Vale was where John Constable, often claimed to have been the finest-ever landscape painter, lived and worked in the first half of the nineteenth century. Walker found this neglected monument by chance when walking in the landscape of Dedham. Having selected it as a suitable subject, he planned the shot carefully, setting the folly off-centre within the frame and balanced visually by the large tree nearby. The building draws the eye into the landscape beyond the watery foreground plane and sets the scale of the picture. Constable's atmospheric skies are a famous aspect of his work: as if by deliberate contrast, the sky in this picture is quite flatly tinted, but the colour interest is strongly developed in the patterns of movement on the

river. The warm earth colours of the land are counterpointed by cool blues, both reflected in the rippling water. The effect of cold, clear light reflecting from the white pillars of the folly complements the wintry aspect of the bare trees lining the riverbank.

Juliette Soester was reminded of Claude Monet's later paintings when she came upon the picturesque bridge spanning a waterlily pool at the home of Sir Michael and Lady Sobell. The scene was almost a direct reference to the Japanese bridge in Monet's water garden at Giverny, which he tirelessly painted throughout the final years of his life. Soester found also that the darkness of the foliage cover against the lighter tones of the water and flowers recalled childhood memories of exploring the landscape. She shot only this single image and has printed it in full format, so that it exactly

**Annie Colbeck**

The image of a lone swan is handtinted in a way which emphasizes the variety in nature's colouring. Colbeck usually applies colour to a small part of a picture to bring up a focal point, but in this case she decided to work by a reverse process. The white swan is only slightly coloured to emphasize its lightness while its surroundings are fully tinted with a range of greens subtly modulated to suggest the variety of the riverside undergrowth- blue-green, emerald and yellow-green - and Colbeck has added warm touches of earthy browns.

represents the scene as she saw it on that day.

A chance episode had caused Soester to review her response to landscape and to think more widely about the possibilities of the handtinted image. When driving with her children through the countryside of Wales she was surprised by their apparent indifference to the beauty of the landscape. Their response was that it was just all green, there was too much green. She realized that the eye can become so saturated with the general effect of a colour that it ceases to appreciate detail and variation; she described this reaction as being almost literally 'unable to see the wood for the trees'. Her feeling is that ordinary colour photography produces a rather more obvious effect which can mask rather than display the potential of the image, unlike handtinting. With handcolouring techniques, it is

**Clint Eley: Orwell Estuary**
Eley thought this picture particularly suitable for handtinting, and worked with very dilute colours to build tints so subtle as to be in some parts almost unnoticeable. In fact, the most intense areas of colour appear to be in the most distant part of the landscape, on the far riverbank, apart from a few flashes of stronger colour in the middle distance and foreground, but overall the integration of the tones and colours is controlled and gently atmospheric.

possible to accentuate the natural qualities, to select or interpret them in a way which demands that the viewer take a second look.

Annie Colbeck, whose interpretation of a swan appears on page 67, uses both oils and watercolours in her work, often developing the hues very subtly to echo the slightly faded, soft colouring typical of old-fashioned tinted photographs, which were the original inspiration for her investigation of handtinting techniques. The swan is worked in watercolour using brushes and cotton wool to apply the diluted medium. The colours are built up layer upon thin layer to achieve a gradual density. Annie Colbeck uses both oils and watercolours in her work, often developing the hues very subtly to echo the slightly faded, soft colouring typical of old-fashioned tinted photographs, which were the original inspiration for her investigation

**Above and right**: Sue Lanzon's pictures were taken on infra-red film which set the curious reversal of tonal values. The picture of the sloping wall (above) was firstly bleached as if for sepia toning, but was gently coloured with a blue toner before completing the sepia processing. In this way Lanzon created the contrast of yellowed mid-tones against the blue-tinted shadows. In the foreground the picture has a texture which almost suggests a secondary image scorched onto the grass and stone.

of handtinting techniques. This example is gradually worked up in watercolour using brushes and cotton wool to apply the diluted medium.

## The open landscape

For his wide-format shot of the River Orwell estuary in Suffolk (previous page), Eley visited the site at five in the morning on a day in early summer, when he knew there would be clear light over the estuary but no people in sight. The openness of the landscape is well served by the breadth of the shot, which is emphasized by the curve of shadow across the foreground.

The mood of the image is strangely ambiguous, since there are all the signs of activity represented by the boats and riverside structures, yet no sense of the life of the estuary in human terms. The viewer is unsure whether the vista is temporarily or permanently deserted. This stillness was one of the qualities Eley was seeking in this early-morning view, which he has aptly described as 'a picture which no one else sees'.

# A sense of history

The work of Sue Lanzon includes landscape elements usually in combination with architectural features. She travels widely and draws her subjects from countryside and cityscape both in exotic locations and close to home. Her castle views are strongly abstract images: the fortified wall on a rising mound appears as a solid wedge of pale tone and colour against the black sky; in a closer view of the castle buildings, the crenellated walls form an interlocking pattern coloured with metallic greys.

The third example of Sue Lanzon's pictures is a complete contrast of mood and image. This is an intriguing view of the 'organized' landscape within a town setting, seen in Southern Italy. The colouring provides a vividly sunlit effect and the regimented palm trees with their pineapple-like texture provide the definition of space and form. Two bound trees standing

**Sue Lanzon**

The unusual colour quality below comes from a variation in the processing of the print, which was left face down in the fixer for 24 hours. This causes the blacks to turn yellow and creates the grainy metallic effect in the greys. In this image the colour contrast emphasizes the planes and angles of the castle walls, at the same time conveying a rather mysterious atmosphere appropriate to the subject of an ancient, time-weathered building such as this.

**Sue Lanzon**

The colours in Sue Lanzon's third picture of southern Italy are entirely provided by intricate crayon work on the black-and-white print. The detail is gradually worked up within each area with crayons that are kept pin sharp in order to enhance the complex latticed textures of the trees and foliage, and to develop the strong hues and tones which suggest the bright sunlight that illuminates the scene.

# Handtinting Photographs

**Gerry Reilly**

The heavy grain of the picture, reminiscent of the effect of densely worked brushstrokes on canvas, is due to the fact that this is an enlargement of a small section of a 35mm negative. The film is infra-red, which already provides a high degree of granulation, but the decision to blow up a selected portion of the image means that this quality is further exaggerated.

In keeping with the mood and associations of the picture, Reilly first gave the entire image an overall sepia tone and then used thinned oil paints to build the colour intensity by overlaying light, transparent paint layers.

sentinel at either side of the picture area create a frame for the spreading shapes of the centre group, as if this were an elaborate stage set.

Warm light is also an important element of Gerry Reilly's river view (below) this time washing over an inhabited landscape which returns us to the influence of Impressionism so often acknowledged in modern landscape art. The picture was taken in Regents Park, London, but has a leisurely, uncrowded atmosphere not always available, even in the parkland areas of this densely populated city. In talking about this picture Reilly particularly mentioned that aspect of landscape as a subject for handtinting - that you can make anything of it, and change the mood completely, in a way that is not so easy with figure subjects.Reilly stresses the fact that when selecting a subject for handtinting, you must start with a good image and use the colours to enhance it: adding paint tends to emphasize, not disguise the original image quality or draw attention to poor photographic technique.

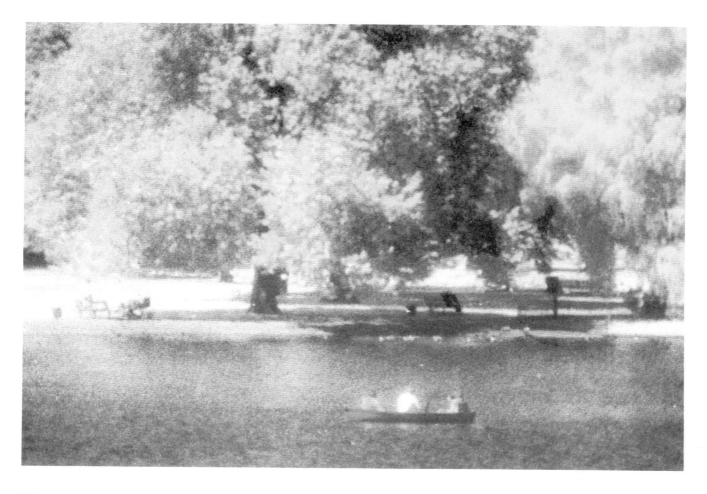

Darkroom decisions are therefore very important.

The final picture in this section is a collaboration between Nihon Token and Michael Dean. It shows a group of Japanese teapickers in a rural landscape (above), an unusual choice of subject and one which bridges the gap between contrasting preoccupations in image-making. It evokes quite different cultural resonances from those in the previous images, in both form and content. The attitudes of the figures, facing in diferent directions, some turned away from the camera, suggest a temporary pause in their usual activity which corresponds to the stillness and sense of mystery conveyed through pure landscape views.

**Nihon Token and Michael Dean**
This picture was tinted by the technique of applying watercolour to a glass slide, with the relatively strong colours threaded through the patterns of the clothing and into the textured landscape background.

# Cityscapes

For many photographers, the natural subjects of their craft lie in the things which are closest to them, so it is not surprising that the environment of the city in which they live or work frequently becomes the focus of their images. Cityscapes perhaps offer the greatest range of choice, including all the varied visual elements - people, still lifes, landscape details, and the complex structures of still-evolving architecture, from tiny side-street shops to vast mirrored skyscrapers. The shape of a city and the activity of its changing life offer, too, opportunities for incidental one-off shots snatching an unexpected moment or serial views documenting a particular location in studied detail. The quick eye can take on board the central dramas, the innumerable sideshows and the still moments of peace or loneliness which co-exist twenty-four hours a day in any city of the world.

Helen Z used pure photographic dye pigments and carefully worked each leaf using a fine pointed sable brush to let the natural tones shine through.

## Handtinting Photographs

Helen Z approached the commission on the right almost as a basic exercise in handtinting, simply to enhance the visual impression of a straightforward black-and-white photograph by adding colour. First of all she diluted transparent photographic dyes in red and blue then loaded a cotton wool swab. With this she laid down the first fine layer of colour, left it to dry naturally and then laid another layer of the same dilution on top until she had built up a colour of the required intensity. The colour values present a classic opposition of warm (red) tints against cool (blue) but they are so subtly merged and interwoven through the mirrored grid that the surface gains a powerful luminosity. With the sky treated in the same way, the image has a coherent logic in which the handtinting is a completely integrated element.

Adding selective colour to a photographic image allows the artist to alter the interest of the shot, as was the case for Helen Z when she was commissioned to handtint a picture of a mirror-clad office building. The building itself is an interesting enough structure, with the stacked planes of the facade and the intricate grid established by the pattern of glass squares uniformly covering the frontage. Its authority is emphasized by the choice of a low-angle viewpoint giving height and lateral depth to the structure.

The photograph also presents a graphic contrast of tonal values in the white-on-black lettering of the company nameplate and the solid black of the downward-facing planes set against the linear framework and reflective facets of the mirrored surface. A second level of textural density comes from the central section of the picture, in which the angles of the facade produce a more complex criss-cross effect where the reflected pattern intersects the actual grid.

Lanzon obtained the basic image for the striking study in purple and blue shown above by printing a colour negative onto black-and-white photographic paper. This produced the dramatic negative effect of the blackened sky. For each separate area of almost flat colour, Lanzon blocked out the surrounding areas of the image with a low tack soft peel masking film before plunging the whole print into a dye-bath. The length of time the print remains in the bath dictates the density of colour. To obtain a purple as deep as this may need as long as half an hour. The moisture can then be

**Sue Lanzon**

A similar perspective effect was selected by Sue Lanzon in her photograph of a narrow New York skyscraper flanked by the rising sides of neighbouring buildings but the colour treatment could hardly be more different. Lanzon has chosen hard edges, reversed tones and strong colour contrasts.

# Handtinting Photographs

**Sue Lanzon**

The picture above was shot with a very fast recording film which gives a prominent grain to the image like the structure of a pencil drawing. Picking up on this quality, Lanzon has introduced colour detail to the buildings using crayons and continuing to select from a colour key of light pastel tints. She finds that a subtle scheme of this type sometimes requires the black-and-white print to be lightly bleached to remove over-heavy grey tones and open up the grain, so that the colours have more clarity when overlaid on the existing tonal range of the image.

driven off using a hairdryer for swift drying or left for a couple of hours at room temperature before the film is carefully removed. The masking process must be carried out with extreme precision. By cutting the film with a fine scalpel blade, broad shapes and delicate details can be cleanly isolated for colour treatment.

Lanzon masked the dark purple area before plunging the print into a bath of dye for a shorter period of time. As the mask is a low tack film it does not lift the colour underneath although it is not advisable to leave it on for more than a couple of hours. The final result is a powerful and ambiguous composition with its own abstract properties.

A visitor's impressions of New York are, however, likely to be as various as the lifestyles enjoyed in this multi-layered environment. Lanzon's

colour interpretations in two other pictures of the city's unique architectural style represent a gentler, more receptive atmosphere. The background to the view of the Pan-Am building (left) shows a soft pink sky also created by masking and dying that selected area of the picture, this simple change of tone and colour providing a complete contrast to the mood evoked by the hard slabs of strong purple in the first example.

New York's famous skylines have become familiar even to those who have never seen the city itself. A long view across the river (below) shows the unexpected variety of the densely packed skyscrapers and reduces them to a manageable scale in the viewer's mind. Using the complementary pairing of yellow and violet hues, Lanzon has created a clean, wintry sunlight flooding the view. Though the yellows are sometimes applied at full strength they have a certain coldness offset by the muted mauve and blue tints. The combination of those colours gives a coolly vivid illumination to the scene.

**Sue Lanzon: New York**
The effect which Lanzon describes as the 'marble sky' is obtained by using fine, waxy watercolour crayons. She draws into the image with the crayons, sometimes allowing the linear marks to stand out clearly, at other times softening and spreading the colours with her fingers to blend the tints. In areas where there is already a great deal of grainy and linear detail, as in the facades of the buildings, the crayons can be used quite precisely to fill in the shapes, while in open areas such as the sky and water, the colours can be more loosely woven into the minimal detail of the underlying photograph.

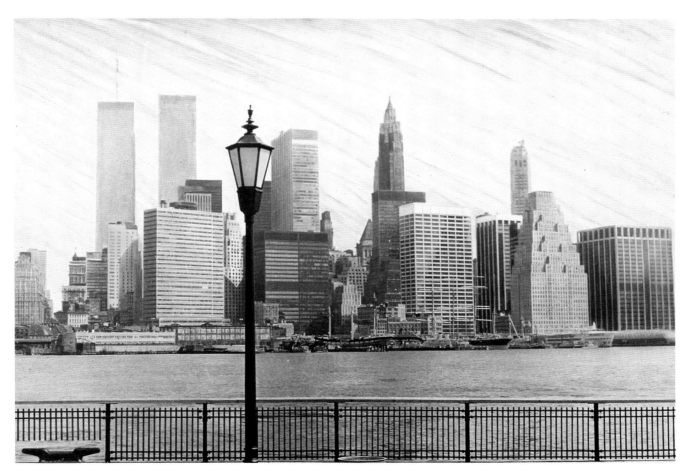

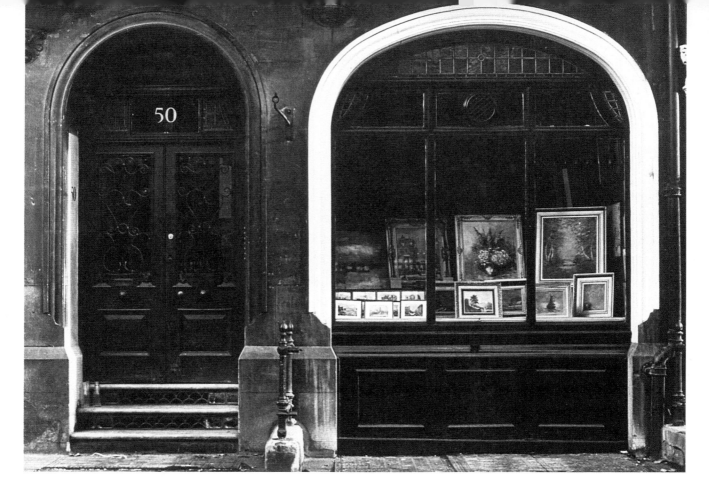

Helen Z softened and 'warmed up' the tonal contrast of this photograph by partially sepia-toning it and letting it dry completely before adding colour by hand, using transparent photographic dyes and a fine-pointed sable brush. She selected only the details contained in the pictures inside the shop window, apart from a tiny hint of gold in the numerals on the front door. Using colours appropriate to each subject, she has 'painted' the pictures once again, restoring their attraction to the viewer's eye just as in the window display they might attract attention after a passing glance. The detailed texture and delicacy of the colouring demand a second look.

## An eye for detail

Returning to a more intimate scale, another work by Helen Z captures the charm of old-style buildings, this time in London, where she came upon an antique shop front with a carefully arranged window display of oil and watercolour paintings. The gentle curves of the door and window arches immediately offered a beautifully balanced, though not symmetrical, composition.

Helen Z took this photograph straight on, letting the pleasing proportions of the architecture speak for themselves. She produced a print of the subject showing a strong contrast of tones, with the white window surround drawing its curve across the heavy greys of the facade and standing out clearly against the glossy black of the door and window panelling.

Helen Z describes the effect of her handtinting on this print as a kind of layered response: first the whole picture is seen and appreciated as a delightful image, the sort of thing someone might wish to hang on their living room wall to be enjoyed for its own sake. Then the tinted detail draws the eye further into the picture and the viewer becomes absorbed in the colours and textures. Helen Z equates this with the dream-like possibility of actually entering the picture, a story-book concept which has had an abiding fascination for artists.

The same eye for detail allows Helen Z to focus on the more mundane aspects of the city, even its debris, and give them new life. Her deserted park bench (see pages 76-77 ) was an early exercise in the art of handtinting, but one which certainly justified her continued exploration of the medium. She saw this rather stark subject as an opportunity to compare the juxtaposition of subtle and intense colour effects, applying no more than a hint of colour to the slatted bench, where textural interest is minimal, but giving the overhanging leaves a good strong colour close to their natural hue.

This approach gives an abstract sense of the picture as horizontal bands of pattern set against the deeply shadowed background. It puts faith in the notion that a simple idea is often also the most effective, with strikingly successful results. The colour treatment is as economical as it can be: for example, there is a cluster of leaves at the base of the tree, behind the left-hand end of the bench, which Helen Z deliberately left uncoloured, in order

**Helen Z**

As with the antique picture shop, Helen Z sepia-toned the photographic print of Autumn leaves (below) just enough to give it depth and warmth. She wanted to keep the leaf colours light in order to preserve the crisp texture of the veining, so chose washes of yellow and magenta diluted with water and applied with a brush, to pick out the central leaves. These two colours are components of the sepia background tone, so the transition of colour through the image is harmonious but at the same time distinctive. Sepia toning softens the overall effect and helps to integrate the local colours.

## Handtinting Photographs

James Walker's picture, above, was recorded on lith-film to create a hard image. The impressive sky was shot separately on Tri-X film and was superimposed on the photograph of the factory using specialized darkroom techniques. The composite picture is an example of the ways in which the photographer can manipulate the 'objective' vision of the camera in order to create a particular atmosphere. Sometimes these techniques are used to introduce a surreal or unexpected element to the image. In this case, the effect is to emphasize the brooding presence of the buildings by setting them against one of nature's more spectacular backdrops.

to preserve the overall balance of the view. This is the type of decision which is entirely in the handtinter's control, whereas colour photography would have made those leaves green, because that is what the camera would have seen.

The final example of Helen Z's work (previous page) in this section somewhat redefines the idea of cityscape, covering as it does perhaps less than a square metre of urban ground. A road drain becoming blocked by fallen leaves is a pretty unremarkable sight, but this is precisely what attracted Helen Z to the idea of using the subject for a handtinted photograph. She wanted to take the interesting aspects of the image and concentrate it, through the use of applied colour, to produce something beautiful out of the mundane. The broken surface around the metal grille, and the grass growing from its crevices, suggests a site which is uncared for, an object which has no presence other than the functional.

Eley's picture is shown slightly out of context here: it is from a series taken to form loose-leaf inserts for a promotional brochure. The client was a company offering space and equipment for filming, an activity likely to be intensive, colourful and costly. This knowledge makes this otherwise typical city warehouse a private and businesslike facility of specific value, rather than a lonely edifice half-forgotten in an uninhabited street.

Clint Eley was aware that the 'product' on sale here, primarily useable space, gave him little identity from which to build an attractive package as compared to, say, a brand-name consumer product. Yet advertising the desirability of his client's service was equally the point of this exercise. Making use of grainy photographs and subtle handtinting, he was able to create a particular feel for the location which suggests that potential users could work pleasantly and efficiently within this space. The colours enhance the basically straightforward photographic shots intended to demonstrate the range of the facilities, and give them a distinctive style.

# The industrial cityscape

James Walker has moved into epic scale for his picture of a disused factory building starkly lit against a darkening sky . He came across the factory by chance while driving through the industrial docklands of east London and, having formed an image in his mind, went back to the studio to fetch his equipment and returned later to take the shot of the derelict building (page 84) using more advanced darkroom techniques to superimpose one image onto another. Imagine those clouds rolling over a blue, sunlit sky and you have a very different sense of the picture's potential. By working in acid tints of orange, yellow and purple, with a combination of transparent oil colours and inks, Walker has underlined the threatening aspect of the cloud-filled sky. These colours are used again in the foreground to form a pictorial link through the deep perspective view. The handtinting enhances the spatial depth and gives the industrial complex a sense of splendid isolation far removed from its everyday presence in the urban wasteland.

A similar sense of abandonment could be felt from Clint Eley's slant-angled shot of a London warehouse building (previous page), its symmetrical frontage also silhouetted against a heavy sky. The absence of human activity and the low-angle view causing a slanted perspective both contribute to the desolate mood.

# Contrasting moods

Another artist taking an interest in the downside of city life is Mark Hamilton, attracted by the graphic immediacy of its imagery. The boarded-up facade of the Flamingo Club displays the peculiar charm of disintegration and forms a strongly patterned composition with its corrugated covers, torn posters and broken paving.

However, Hamilton had reservations about the original black-and-white print. The figure, particularly the feet, legs and shoulder, had disappeared into the background because the film had been over-exposed. Over-exposure had also caused the building on the right-hand side to disappear and the eye is attracted to the dark holes of the upper windows and boarded-up door. Instead, Hamilton set out to lead the eye to the figure striding past, creating a celebration of this ravaged subject and turning an unpromising print into a comment on inner-city decay using the medium of

Mark Hamilton was not completely satisfied with this original black-and-white print. The figure recedes into the background because the tones of the dark upper storey windows and boarded-up door are darker than the foreground. The medium of handtinting allowed Hamilton to solve these problems of composition but still make use of the tonal texture in the print such as the weathered plasterwork and stained wooden boarding. Areas which were indistinct, such as the man's shoes, could also be cleaned up and redefined.

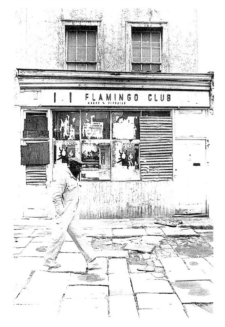

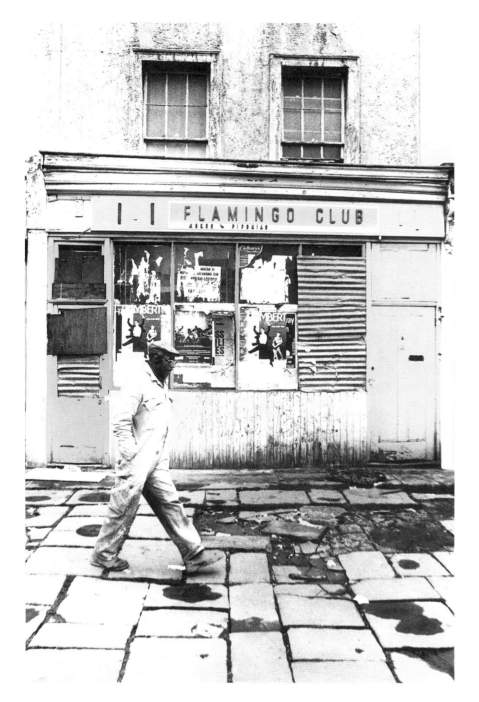

**Mark Hamilton: Flamingo Club**
Although the figure provides movement and direction in an otherwise static subject, the completed image is richly self-contained. The pale colours soften the vertical backdrop formed by the facade of the club throwing into relief the overalled figure who purposefully strides across the uneven pavement. Tiny dots of stippled paint - grey, blue, brown - were dabbed on selectively with a fine sponge to give more definition to the contours of the figure.

handtinting to change not just the emphasis of tone, but also the presence of actual elements in the picture.

He began by masking certain areas with a low tack, soft peel film to get firm, clean lines around the windows and the edge of the building. He

## Handtinting Photographs

**Mark Hamilton**

In this print, Hamilton masked around the top of the wall and green pipe before applying the light blue sky tone, blotting out areas of colour with cotton wool to give the impression of light clouds scudding across the sky. This he echoed in the solid light blue tint of the concrete band at the base of the wall carefully applied to leave patches of the grainy print beneath. Individual bricks are picked out in warm earth colours, yellow and brown. Offsetting the shadow in the top right-hand corner, the drainpipe projecting above the wall is coloured a vivid green, but its effect is restrained by what appears to be a sooty deposit on the pipework which allows only occasional glints of the pure colour to be revealed. The tonal contrast of the original black-and-white photograph is, in fact, carefully preserved despite the broad application of colour. It establishes the sharpness of the image and the characteristic textures, especially in the precise delineation of the brickwork.

decided that he would dispense altogether with the building on the right-hand side and create an area of sky instead. He used several masking stages around the lettering on the board. First of all he masked the area around the

words 'Flamingo Club' and painted in the blue tone. Once this was completely dry he peeled off the outer mask and cut one to cover the blue tone, making it a little larger all around the edge and reaching down to the smaller lettering to create a perfect white border to the blue. Masking the outer extent of the pink tone too, he painted the colour carefully in around the masks. To create the graded tones on the doorways and in the sky, he flowed the blue tones up against the red while it was still damp.

In order to bring the eye back to the figure, Hamilton carefully coloured the ripped posters around the head but decreased the intensity and amount of colour as he moved across to the right of the picture and away from the figure. Similar treatment of the boarding pulls the figure into the foreground. To further strengthen the figure, Hamilton works up the surrounding paving stones. Looking at the tinted photograph in isolation it would be easy to miss the fact that the paving stones have been tinted were it not for the vivid areas of solid, bright hues flashing out from the smoothly graduated pale tones. By looking at the original print it is clear that not only has a great deal of work gone into the paving stones, but also that without this treatment the figure would still suffer from lack of contrast, and the sense of perspective indicated by the lines between the stones receding backwards would be lost.

The second of Mark Hamilton's city views shown here (left) deliberately concentrates on the static quality of architectural form, but we are not being invited to admire an ancient monument or the award-winning design of a prestigious building. In the same way that Helen Z treated her autumnal leaves (page 83), Hamilton has chosen a mundane subject which you might pass by without remark in some neglected back alley. But by selecting a deliberately deadpan, frontal view and then using applied colour to elaborate and enliven the image, he also has challenged the viewer to pay better attention to the everyday details of the cityscape.

Again the viewpoint confronts a starkly vertical image, an ordinary brick wall with a neat but not very elegant doorway set in it. This is a balanced composition, but the balance incorporates sudden shifts of emphasis: the door sits centrally in the picture but the sections of wall on either side do not form a symmetrical frame. On the left, the top of the wall steps up on a line with the left side of the door frame; on the right, the brickwork disappears into a block of heavy shadow, and at the base of the wall, the strip of concrete facing is suddenly twice the depth of the corresponding strip on the opposite side.

# Handtinting Photographs

**Sue Lanzon: Italian town**

In the gate and patterned screen door above, touches of blue-grey have been introduced to offset the warm colouring, but the handtinting is quite unobtrusive. The intended atmosphere was successfully established in the processes of printing and toning the photograph. The additional colour work enhances the pictorial definition and surface interest.

These quirky and unexplained features (do we see *what* is casting that shadow?) cause minor disruptions which keep the image alive, and these are enhanced by the distribution of colours.

There is a clear visual connection between this picture of Mark Hamilton's and Sue Lanzon's shots of doorways in an Italian town (above and right), but the change of mood is equally evident and this results from both the architectural character and the colour treatments. Hamilton's wall has a rough and ready charm but looks set to resist hard knocks; even its softer colours have an abrasive edge because of the context. Lanzon's subjects show a dilapidated elegance suggesting a *laissez-faire* attitude to life, and are flooded with that warm, yellow light which creates an irresistible atmosphere of continental streets in the middle of the day when shops and doorways close and the cities sleep their way through the afternoon heat. To talk of flooding the image with colour is also particularly apt in terms of the technique Lanzon has used to obtain the golden glow over

**Sue Lanzon**
Having established the general impression of colour and light using a variety of sepia toning, Lanzon worked with crayons to develop the detail. The canopy over the doorway is coloured a heavy blue and its lettering is traced with a cool, pale yellow which remains distinct from the golden mid-tones. A clean, bright yellow is also worked across the mellower tones of the stonework, shutters and window grille to enhance the lighting effect.

the entire picture surface. The prints are immersed in a special toner which turns the greys to yellows, but leaves the black areas as they were originally defined provided the print is carefully watched before the process lightens the blacks. This gives a rich texture and mellow tone to the image.

# Interiors

An interior view presents special problems in that part of the perspective is always missing, because the camera is positioned within the room. The necessity to be selective is a given factor, but a large number of elements are much more within the photographer's control than in relation to, say, a broad landscape or city view. The lighting and atmosphere of the interior, the arrangement of furnishings and objects within the room, the sense of activity or stillness can all be carefully planned and contrived. There is the option to take the location as it is found or to manipulate the setting to develop a sense of illusion. It is interesting, too, that in several of the examples shown here, the photographer has chosen to focus on a detail of the interior, rather than the general space, as a representation of mood and style using the medium of handtinting to achieve this.

Sue Lanzon yellow-toned the photograph for contrast and to cast a mellow glow over the entire view. The print was then vigorously worked with crayons to develop the colours, tones and textures.

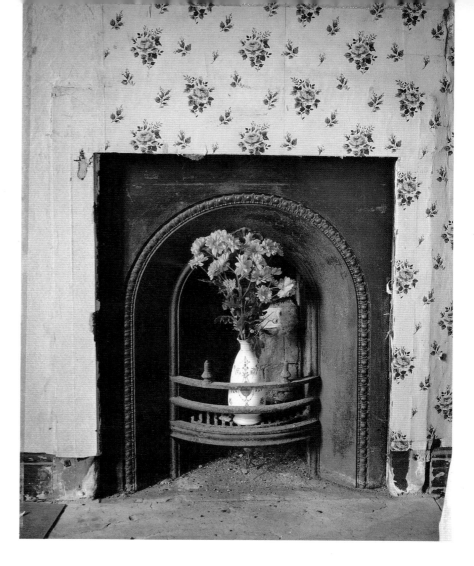

## Inside the room

Sue Lanzon has produced a classic study of interior proportion in her picture of a large-windowed room in East Berlin (previous page). By centring the window wall, she has created a generous perspective which spreads towards the viewer. The composition is almost symmetrical, but there is enough variation in the shape and placement of objects to draw the eye into the detail of the picture without destroying its overall balance.

The effect of brilliant illumination comes not only from the yellow cast initially applied to the print but also from the open composition of the picture and Lanzon's control of light and dark tones within the colour work. The vivid golden and orange hues are balanced by the subtlety of muted blues and greens. Lanzon has applied bold slashes of black and blue-grey to emphasize the deep shadows. The rough texture of individual crayon strokes gives the image great vitality, but this is combined with a softer effect of blended hues which Lanzon has achieved by spreading the coloured marks with her fingers. It is difficult any longer to identify the

**Andrew Sanderson**

Before handcolouring, Sanderson sepia-toned the print above to replace the coldness of hard photographic greys with a more subtle background colouring. Sanderson supplies the colour details with delicate precision - the living flowers and foliage, the wallpaper pattern and the glazing detail on the ceramic container - to create a sympathetic study of this isolated subject.

original photographic components of the image when every surface has become a complex network of colour detail. To a large extent drawing technique has taken over from the photographic qualities of the image, producing a quite different and more impressionistic form of visual record.

There is a distinct sense of place in Andrew Sanderson's image of a vase of flowers brightening an unused fireplace (left). The character of the room seems contained within this single detail of its fittings: an open hearth always tends to form a focal point in a room, whether or not it is a source of heat, and it indicates the human touch. Yet there are some unanswered questions in this image. The thoughtfulness with which the flowers have been selected to complement the flowered wallpaper belies the fact that at the left-hand side of the fireplace the wall is shabbily undecorated. The

**Sue Lanzon: Versailles**

The handtinting in the picture on the left is a colour exercise specifically targeted at enhancing the marble patterns. The hard tonal range of the photographic print has been deliberately preserved throughout the image, and Lanzon has selectively treated the stone mouldings with warm pink and brown tints, applied with crayons, which form a luxurious contrast with the colder greys.

# Handtinting Photographs

image expresses a curious paradox of care and neglect.

Another picture by Sue Lanzon similarly takes close focus on a single subject which indicates the grandeur of its interior setting. The marbled bust (previous page) is one of the many elegant incidental features to be found in the palace at Versailles. The sculpture has a natural frame provided by the marble mouldings on the wall. To obtain the greatest variety of tone and texture, Lanzon has taken an angled shot which shows the bust in its own niche but also takes in the more ornate detail of the adjacent panel. The

Helen Z used a combination of techniques to develop the delightful colour qualities of this picture. To obtain the warm pink tone of the background, she immersed the print in a chemical toner, having first masked out the shape of the globe to prevent it from receiving colour. Unmasked, the lamp stands out in clear relief against the flat background.

Helen Z then picked out the flower design on the lamp with appropriate colours, using fine brushes and diluted dyes. She found the toner method the most convenient way to produce a pink tint that spread consistently across the photographic detail, but pointed out that she could have used a broad sable brush or cottonwool swabs to apply the dye colour as a surface treatment to achieve a similar effect.

interpretation is very different from the effect in the Berlin interior ; here the medium is used purely as a means to an end, and the physical quality of the crayons is subordinated to the smooth application of colour values.

Helen Z puts on display a delicate china globe lamp mounted on a wallbracket (left). The lamp has been photographed directly from the front, then printed in the centre of the picture image. The faint tracery of cracks in the plaster wall, far from detracting from the character of the setting, creates a fine 'pencil-line' texture that forms the perfect background for the smooth flower-patterned sphere.

This is a very simple but very effective composition: the emphatic vertical line of the lamp bracket is balanced by the lighter-toned horizontal of the dado rail cutting right across the picture. This linear framework is counterpointed by the circular contour of the lamp.

## Colour moods

Adriene Veninger's work on interior moods also takes in details drawn from her interest in still life and figure studies. Her preoccupation with the abstract qualities of form and colour are evident in two examples (above and overleaf) from a series of six pictures, all differently tinted. These are in all respects highly personal images, as Veninger acted as her own model for the human element, using a time-delay shutter release mechanism to

**Adriene Veninger**
Both Veninger's studies of a woman with tulips (above and overleaf) share a mood of relaxed privacy which comes mainly from the descriptive formal elements. The colour work directs this atmosphere in different ways. The study on the left  has a sunlit richness enhanced by strong tonal definition. The patches of light reflecting off the figure have a creamy warmth; the background hues - passing from orange through pink to blue with shades in between -  have depth and variation paralleling the tonal values.

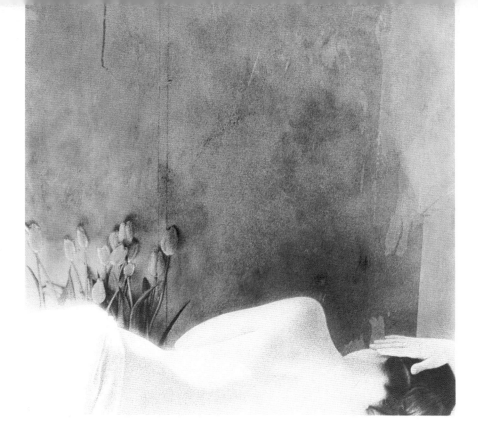

**Right**: Adriene Veninger's second study of a woman with tulips. The overall colour scheme is much bolder and brighter. The colour treatment of the figure, however, is similar with grainy grey shadows on the flesh tones and cold blue lights in the shadows of the drapery. Whereas the first picture may express a sense of complete repose, the second is of awakening and incipient activity.

**Opposite**: Carl Hulme sepia-toned this print to warm up the tonal scale: Hulme thinks that he probably aims for more contrast in the original print when he knows he is going to handtint a photograph to give the image stronger definition within which the colour work can be applied. The handtinting here contributes most discreetly to the mood of the picture. It would be easy to overlook the delicate colour washes which enliven the lighting effects but, once you begin to study the shadows and highlights, vibrant colour detail, touches of cool blue and glowing orange become gradually more apparent. Hulme tried initially tinting the cello with realistic colour, but found this out of keeping with the slightly surreal quality of the image. He decided to use handtinting to enhance the atmosphere in subtle ways rather than to add descriptive detail.

take the photograph. This introduced an element of chance to the composition, as naturally she could not see precisely how the image would turn out. But she also appreciated that it gave her greater control of the basic concept, since there was no need to communicate the idea to another participant.

As with Veninger's still life (page 112), the actual components of the image and their spatial relationships are not immediately obvious, but filter gradually through the viewer's sense of an overall visual impact. The picture can be read abstractly as patterns of light and shade, texture and colour, before a distinct impression of three-dimensional form is realized. What is particularly instructive about these two examples is the investigation of how handtinting can be used to interpret the same image as alternative moods.

## Double take

Any ordinary interior can be transformed into a place of mystery or fantasy, but in the case of the following two handtinted pictures, all is certainly not what it seems. Carl Hulme's study of a cello player (right) is clearly a composed shot, not the result of a chance encounter with an interesting location. If you notice a theatrical element to the design, this is no accident. Hulme works in theatre lighting and was interested in the possibilities of using this medium directly to illuminate a photographic image, rather than

**Clint Eley**

This is a companion piece to Eley's warehouse view (page 85) from the series of pictures commissioned by AKA, a company offering space and facilities for filming. It similarly shows the grainy photographic texture and softly integrated handtinting which Eley established as the style for this commission. This picture has, however, a warmer and more intimate atmosphere than the exterior view, in part simply because the viewer is brought within the building. These qualities are enhanced by the gentle brilliance of the handcolouring, and the inclusion of figures which, by their attitude of involvement with the surroundings, cause the viewer to associate with their apparent interest in the location.

working with photographer's lights. The complicated interior, which gives a simultaneous impression of cavernous space and cage-like confinement, is in fact a theatre set which Hulme borrowed as the framework of this image.

The mechanics of theatre design include using real space in non-realistic ways to suggest a variety of spatial possibilities to the audience. Shallow distances are given an assumed depth; solidity can be contrived from lightweight materials. Lighting is an important element of creating the illusion. Its other purpose is, of course, to establish an atmosphere for the activity on stage, and this is what Carl Hulme has done so dramatically in creating this image. Unlike a play, its significance is frozen by the camera

so this is all we know: there is no beginning or end to the story, if there is a story, except in the viewer's imagination. It can hardly be taken as a simple study of a figure in an interior, however, because of the complexity of the setting and the shadowy presences in the latticed 'corridor' behind the central figure.

The art of illusion is also acknowledged in Clint Eley's handtinted study of a film set being prepared for a shoot (left). Careful contrivance has transformed the interior space into a brilliantly lit exterior, or so it seems. In this case the artifice is demonstrated through the various 'staged' elements that Eley has framed within shot - including a segment of the studio interior beyond the garden setting, and the powerful lights that will simulate a sunlit atmosphere within the enclosed space.

There is a lot going on here, as would be expected in preparation of a working film set. By taking the shot in black-and-white, Eley has reduced the complexity of the visual elements to focus more attention on the mood. The impression that certain parts of the picture have been bleached out by the dazzling lights gives emphasis to a graphic tonal contrast. The handtinting, executed with a deliberately restricted range of warm, high-keyed colours, brings an atmospheric resonance to the image pinpointing critical features within the composition such as the metal work of the lights which echo the dazzling pale yellows of the background.

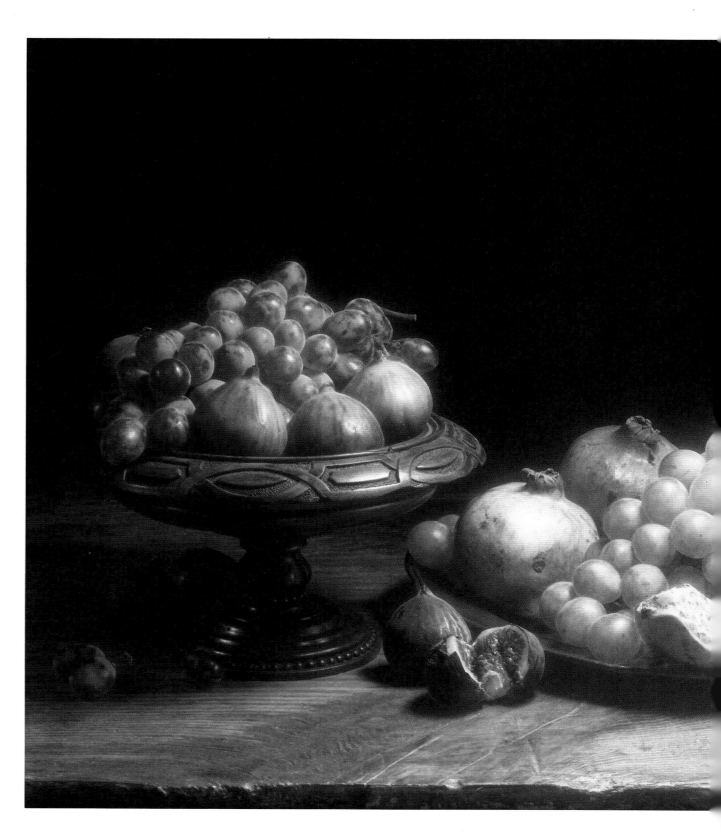

# Still Life

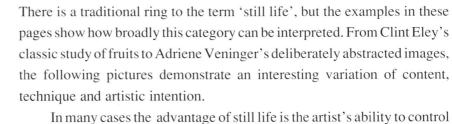

There is a traditional ring to the term 'still life', but the examples in these pages show how broadly this category can be interpreted. From Clint Eley's classic study of fruits to Adriene Veninger's deliberately abstracted images, the following pictures demonstrate an interesting variation of content, technique and artistic intention.

In many cases the advantage of still life is the artist's ability to control every aspect of the composition. The inanimate objects can be selected for specific reasons of form, colour and texture, and can be arranged with great precision to maximize the visual impact. The colour treatment may be manipulated to enhance the realistic character of the image, to concentrate the focal points, or to interpret the picture as a visual composite gradually disconnected from the original subject. Unlike a landscape which simply exists, or a figure which contributes its own dynamics, the still life can be brought out from the undisturbed province of the artist's imagination and subjected to the discipline of a trained visual sense.

**Clint Eley**
This image took Eley two weeks of work using retouching dyes, lots of water, careful brush and cotton wool swab work and a lot of patience.

# The personal scale

The components of a still life are typically small-scale, enabling the artist to place and rearrange them easily until the satisfactory composition is achieved. Traditionally, they are objects readily to hand - fruit, vegetables, flowers, containers and ornaments, personal accessories. This tradition is carried through the examples here, whatever the reason for creating the still-life image, and these pictures show the influence of historical examples as well as the preoccupations of their own times.

Clint Eley has produced an extraordinary homage to the genre in his detailed study of lustrous fruits (previous page), which could have come from the brush of a Dutch master painter of the seventeenth century. This represents an investigation of the capabilities of his medium and of his own skills, and Eley worked on the handtinting over a period of two weeks. The picture is a virtuoso exercise in the skills of applying colour and, just as importantly, as Eley stressed, knowing when to stop. There are no short cuts or technical trickery which can help the artist quickly to achieve such a flawless representation. It is a matter of patiently washing in the colour, washing it out again, and building up fine layers of subtle tints to develop the luminous hues and textural detail.

The ability to render such qualities as the shiny skin of the figs, the bloom on the grapes and the lush juiciness of the pomegranate seeds comes mainly from rigorous observation of the real thing. True, a photographic base offers two-dimensional visual cues which can be developed through handtinting, but the artist must have experience of the colour medium and a concentrated interest in the subject to study how this can effectively be done with applied colours. The precision of colour mixing, setting light against dark tones and warm against cool colour values to model the forms, is a process which evolves out of the actual work of handtinting, informed by a good analytical eye for colour.

A comparable image in terms of subject, but one which radiates a very different atmosphere, is the study of a group of lemons by Alan Randall. Randall collaborates closely with his partner Georgia Loizou, who works on the handtinting, to develop the combination of photographic and colouring techniques which will create the precise mood of the rendering. Economy of design and technique produces here an image which is all the more rich for being rigorously controlled. The brushwork echoes the

highlights and shadows which describe the rounded form and lightly textured surface of the fruits. The heavy shadows and abstract textural effects of the background and foreground planes provide overall interest without distracting from the clarity of the central still life.

Alan Randall started using handtinting techniques in the early seventies because it was at that time impossible to obtain the colour quality he required through film processing. He wanted a grainy, muted surface with subtly modulated hues. It is now possible to obtain colour film which produces a print closer to that style of visual impression, but Randall still finds that handtinting a sepia-toned monochrome print is the best way to obtain the particular definition of the image which he looks for in his work. Randall and Loizou do not consider that they specialize in still life pictures: their work is mainly for advertising and presents them with a range of visual problems to solve. These two examples of their work, however, demonstrate

**Alan Randall: Lemons**

Alan Randall gave the initial photographic print a warm sepia tone. The colour was then added, mainly to the central group but also extended in subtle hues worked across the background. It was applied with brushes layer upon layer to obtain the required intensity.

The clear citrus yellow of the lemons and the warm light red tint of the paper wrapping are carefully modelled to follow the range of tonal values set by the photograph. The authenticity of the image would be destroyed by applying a purely flat colour wash.

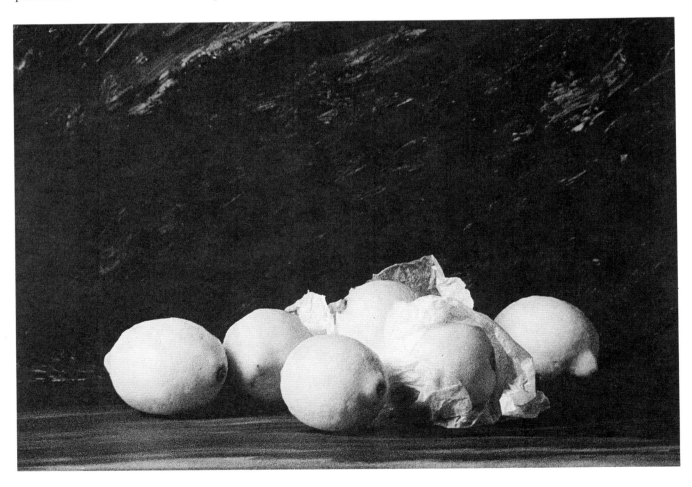

# Handtinting Photographs

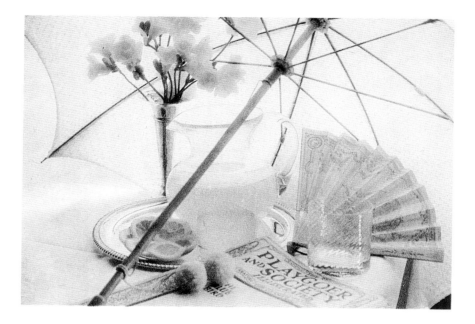

### Alan Randall: Parasol

This print is also sepia-toned. Randall finds the warm quality of the sepia more sympathetic to the colour values he expects to achieve in the handtinting. He uses a high-speed film to obtain the heavily grained texture of the initial image, which is, in places, as loose and vigorous as a crayon drawing. The sensitive brushwork by which the colours are applied enhances this hand-worked quality. Again, the colour is restricted to specific areas of the image and these are treated with due attention to the subtleties of form and texture in the original objects. The flower petals are coloured individually, linking with the yellow-tinted lemon slices: the delicate pattern of the fan is retraced with subtle hues. The balance of the image is closely observed at every stage, and the colours applied to emphasize its intrinsic character.

how beautifully they have developed the special virtues of handtinting techniques. The style of Victorian photography is acknowledged in the summery atmosphere of their still life entitled *Parasol* (above). Elements such as the fan and the copy of *Playgoer and Society* magazine call up the vision of a more leisurely, amiable lifestyle than most of us now enjoy. Whereas *Lemons* (previous page), despite the sepia tone and colour washes, has a distinct flavour of modernity, the parasol still life surrenders easily to a nostalgic mood.

Andrew Sanderson's flower studies have the quality of meticulous watercolour paintings. The tonal structure provided by the monochrome print leaves him free to concentrate on the pure colour qualities. He works using diluted dyes painted on with brushes to obtain a detailed finish based on the colours of the subject as he observes them. Sanderson applies this approach to still life pictures and to landscapes, which form an important part of his work. He has experimented with the abstract properties of colour, using non-realistic interpretations, but has preferred to return to a more strictly observational form of colour rendering.

Delicacy of form and colour is brought into focus in a simple arrangement of carnations and gypsophila (right). Each flower petal is individually painted to develop variations of colour intensity corresponding to the way the forms are modelled with light and shade in the original image. At first glance it is easy to underestimate the depth and precision of the colour work,

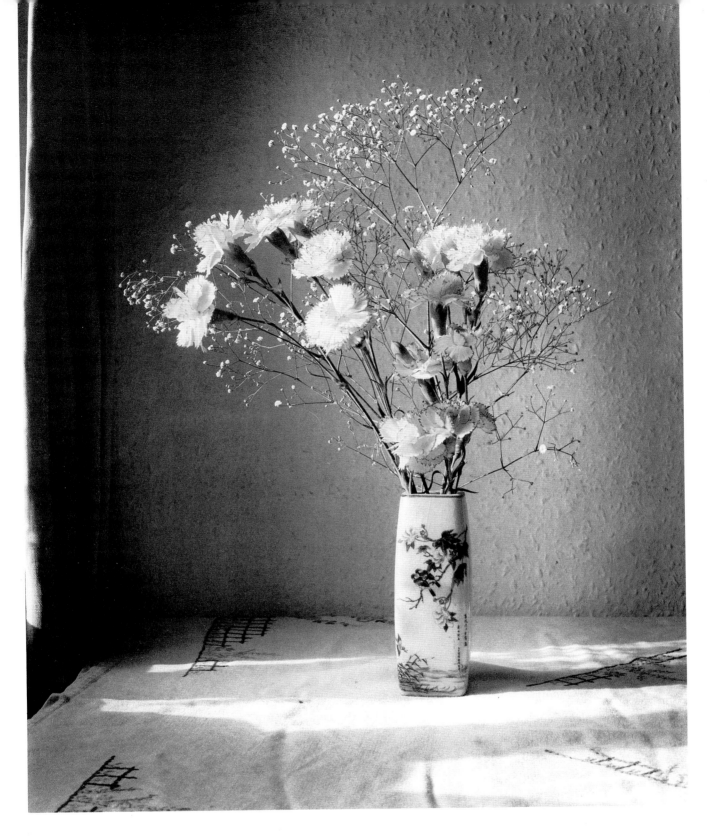

because the overall effect is so immediately satisfying. Closer examination shows the careful modulation of tints by which this delicate result is obtained. The elaborate detail of the tiny gypsophila flowers and slender carnation stems also requires meticulous technique to introduce the almost

Andrew Sanderson left the monochrome background untouched, highlighting the clear colours which he applied to the central subject.

imperceptible colour changes which provide such a realistic impression. Sanderson's appreciation of subtle detailing is further displayed in the painted ceramic container, sympathetically matched to the flowers and extending the sophisticated colour and pattern of the subject.

The components of a natural still life are often selected for their freshness and perfection - clear, unblemished fruits and newly-blooming flowers. In the second flower study shown below, Sanderson has reversed such expectations in choosing to present the distressed beauty of dying roses as a suitable subject for a still life. As with the carnations, the overall composition is deceptively simple. A gentle drapery of crushed fabric forms the background, its antique colour and texture corresponding to the fragility of the papery flowers and leaves, its gentle folds and contours echoing the bowing heads of the roses and the smooth, elegant curve of the sturdy vase in which they stand. By contrast, these are displayed on a flawless, polished surface: this clean element of the design is a well-chosen complement to the textural complexity which surrounds it.

## Still life outdoors

A complete change of mood in still life arrangement is contributed by Walker in his 'found object' composition showing an unoccupied deckchair

**Andrew Sanderson**

In the handtinting of this picture, Sanderson has treated the entire surface as a canvas for colour work. Unlike the previous example, there is no acknowledgement of the photographic greys which form the picture base: these are entirely converted into a mellow colouration. The warm golden tones of the drapery are touched with pink and red shadowing, echoing the richer hues of the flower petals. Again the careful side-lighting of the still life setting enhances the depth of the composition, but the colours have a softened, fading quality appropriate to the subject.

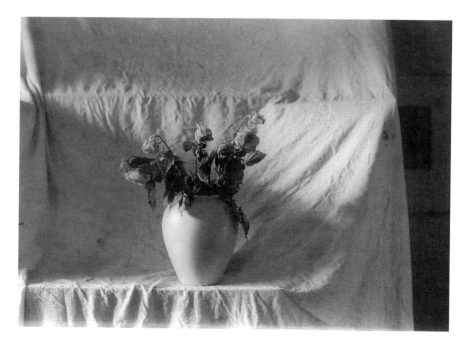

**James Walker: Palace Pier**
The sense of distance demonstrated by the coastal horizon line is obvious from the context, but, broadly speaking, Walker has treated the picture as a two-dimensional exercise in colour and pattern. The realistic elements are preserved while the graphic qualities are enhanced in the handtinting. Walker has applied the thinned oil colours which he favours because they enable him to achieve a vivid but transparent colour effect. These provide the strength of his colour interpretation without disguising the sunlit tonal key established by the photographic print.

on Brighton's Palace Pier (above). This is a different interpretation of scale and subject in the still life category. The composition arrives by chance rather than by arrangement: the photographer's role is to recognize and develop the chance opportunity.

What seems to have attracted Walker to this subject is the graphic

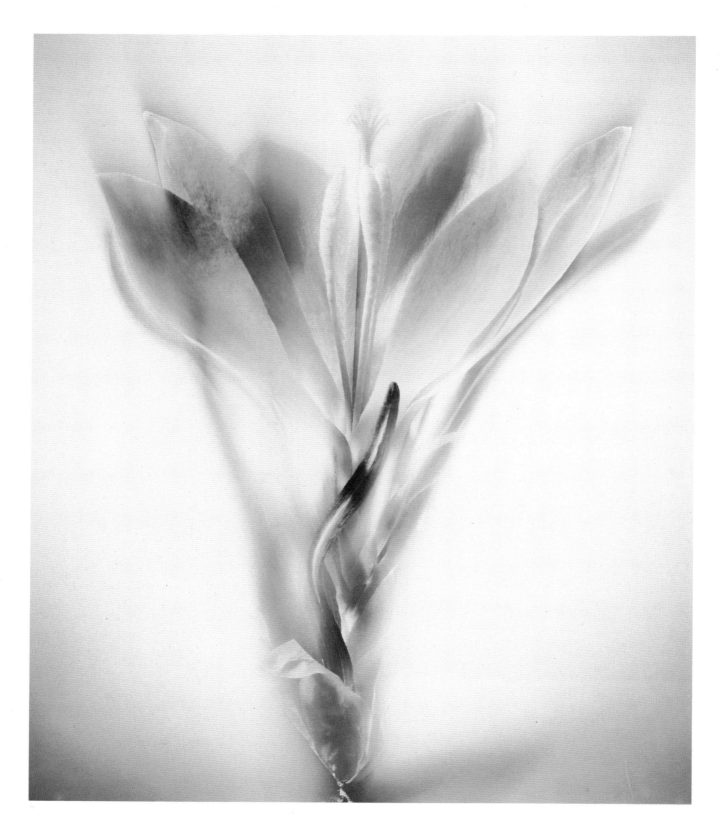

organization of the image, the striped patterning of the slatted pier deck and bright chair canvas in the foreground and the more fluid and complex shapes of the ironwork balustrade seen through the framework of windows in the pier's central divide. The ironwork detail is emphasized with extreme subtlety by the cast shadow of its unseen counterpart which falls onto the flat planes of the vertical panelling.

## Still life and fashion photography

A commissioned picture for an advertising image or fashion spread in a magazine presents the photographer with a number of given elements; specifically, the content of the image and possibly the overall style of the representation. Clint Eley approached his arrangement of lipsticks on page 27 as a strictly formal design. This shot was taken at the end of a commercial session: the commission required a colour photograph of the lipsticks which Eley shot according to the brief for the job. He then took for himself a black-and-white version of the image in order to investigate its colour potential using handtinting techniques.

Eley's interest in developing the subject in this way was to dramatize the depth of colour in a uniform visual presentation. The symmetry of the lipstick casings and their glossy texture includes a surprising degree of surface variation. Through handtinting, Eley was able to enhance this variety, firstly and most obviously by emphasizing the colour differences in the actual lipstick tips. In this detailed elaboration, he has carefully preserved the fibrous quality of the material while developing the richness of colour. He has not depended on simply overlaying colour washes on the monochrome detail of the original print: the depth of colour comes from the massed effect of tiny brushstrokes in a range of hues. Though the end result basically identifies the individual lipsticks as orange, red and purple, each one contains dashes of colour from yellow through red to blue which combine optically to produce the coherent impression of brilliant colour.

A similarly meticulous analysis is applied to the colouring of the shiny black and gold casings. Here again, Eley has thoroughly examined the apparently even surface quality to identify the subtle colour components which will bring the image alive. His solutions to the rendering include different depths and strengths of blue and blue-grey enlivening the dark

**Tim Hazael: Crocus**
The airbrushed effect on the picture opposite was achieved by careful lighting and the use of a filter which produced a flaring effect around the crocus. Hazael then made a print on Agfa portriga paper which produces a matte velvety sheen that takes colour well. He sepia-toned the print and began to work up the colour details using water soluble photographic dyes applied with brushes.

This picture took about a day to complete. Interestingly the crocus was a model made for an advertising shot for a drug company campaign. It was created from paper which was then waxed to produce the correct texture.

# Handtinting Photographs

**Adriene Veninger**

Veninger works in oils but controls the colour values to produce a composition of richly varied but muted hues. A restricted colour scheme demonstrates the complementary pairing of blue and lilac. The 'blocked' effect of using broad colour areas emphasizes abstract elements in the design, but there is a range of textural and colour detail which stimulates the viewer's interest by allowing different associations and interpretations to be brought to the image.

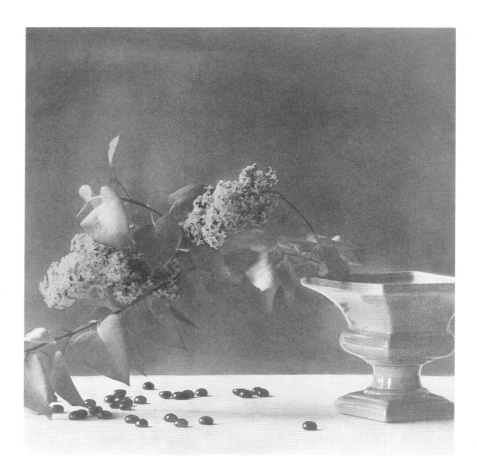

tones. A particularly vibrant effect is achieved by enhancing the glints of gold reflected between one lipstick and the next in the shiny casings. These are the kind of details which not only convey the expensive elegance of the subject but also lift the handtinted image into a class of its own, combining the best elements of painting and photography.

## Towards abstraction

Adriene Veninger combines technical expertise with a particularly inventive visual sense to produce her semi-abstract still lifes. Her approach is to set up the shot such that the resulting image has the abstract qualities which she requires. Veninger prefers not to manipulate the composition through the darkroom techniques of developing and printing but, having achieved the framework of the design in the initial photograph, she concentrates on the colour potential to take the composition further from its realistic context.

The conventions of still life imagery are not important to Veninger: her

picture subjects act mainly as a vehicle for interpretation. She deliberately applies 'a certain amount of disguise' to the recognizable forms.

The surface texture of her flower study (left) is enhanced by Veninger's initial use of recording film to produce an overall grainy texture in the monochrome print. Veninger does this deliberately to eliminate the expectation of a 'pretty picture' of flowers, and by doing so ends up with a slightly abstract feeling. The horizontal line across the image automatically suggests a conventional division of vertical and ground planes accentuating the central subject while the handful of black beans gives added weight and texture to the foreground.

# People

The human figure has always been the central subject of western art: landscape, for example, is a comparatively recent subject and until the nineteenth century interested artists only as a potential background for figure work. The desire to represent and relate to fellow humans beings has produced a particularly rich genre in all the various artistic disciplines. It is a naturally important aspect of photography in its role of recording the times in which we live and the ways in which we respond to them.

Media images for advertising and editorial purposes make common use of figure photography as the central point of association between the viewer and the picture content. The fine art context is also still strongly represented in photography and handtinting, providing a way of examining oneself, or the various essences of 'human-beingness', through the medium of others - faces, bodies, clothing, accessories, locations. Some of the examples in this section are bang up-to-date in mood and style; others call up impressive historical references, but these are necessarily reinterpreted through current visual vocabulary and equally present distinctively contemporary images.

**Roderick Field**
A witty and skilful piece of handtinting from Field, proving that understated colouring is often more effective than heavily overworked prints.

## Figures in outdoor settings

Snapshots and reportage pictures sometimes succeed by sheer good luck in finding the right person in the right place at the right time to make a perfect photograph. More often, and certainly in professional work, the apparently casual image of a person going about their business or taking an idle moment's rest is the result of hard work, careful contrivance and the patience to wait until things fall precisely into place. James Walker's atmospheric image of a man walking in rainy streets (above and right) is

**James Walker**
The high-contrast, grainy quality of the image before Walker started to handtint it is clearly seen in the black-and-white version shown here. The print was made on lith paper to cut out the softer half-tones and emphasize graphic contrast.

116

one which precisely demonstrates this principle.

There are several elements here which might be the products of chance, but the picture was carefully set up in a night shoot at a selected location. This was a cobbled mews which provided the sense of enclosure and the heavy foreground texture. Photographer and model waited for the rain to fall heavily enough to give a slick wetness to the cobblestones. A long exposure was needed for the night shot - Walker made use of car lights to create dazzle, since he was looking for a moody effect rather than

James Walker worked with transparent oil colours in yellow and pale sepia tones to develop the lighting effects. Limiting the colours in this way adds to the drama of the image as the harsh transitions through light and shade are preserved. Walker used fine brushes to apply the thinned paint to areas of delicate detail and cotton wool to swab in the broader washes of colour.

# Handtinting Photographs

**Carl Hulme**

In this work by Hulme the tints, brushed in with dyes, are applied to broad areas of the picture, but very delicately to enhance the sun-washed effect. There are warm pink lights over the door and wall giving depth to the pale tints of yellow and blue. The general atmosphere of warmth and light was assisted, before application of surface colour, by an all-over sepia tone intended to soften the monochrome range.

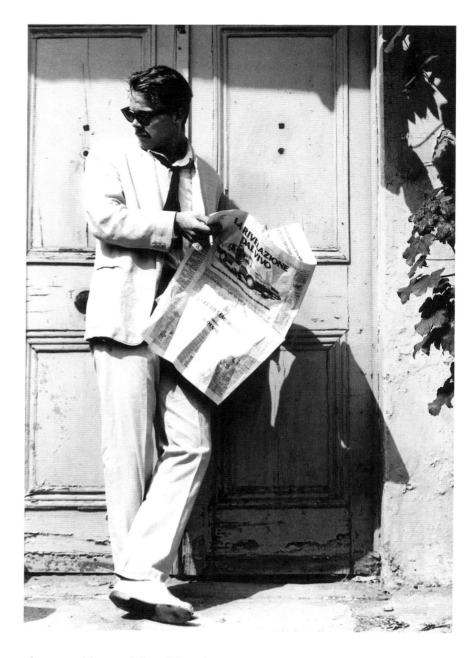

photographic precision. The picture captures the figure in motion at the exact moment when the dark shape of the man's head and shoulders is framed by the archway at the far end of the mews.

A similar illusion of the passing moment, but one which expresses a very different mood, is described in Carl Hulme's picture of actor Paul Deavin posed against a shabby painted door (above). Hulme wanted to emphasize an Italian feel to the picture, achieved not only through the man's

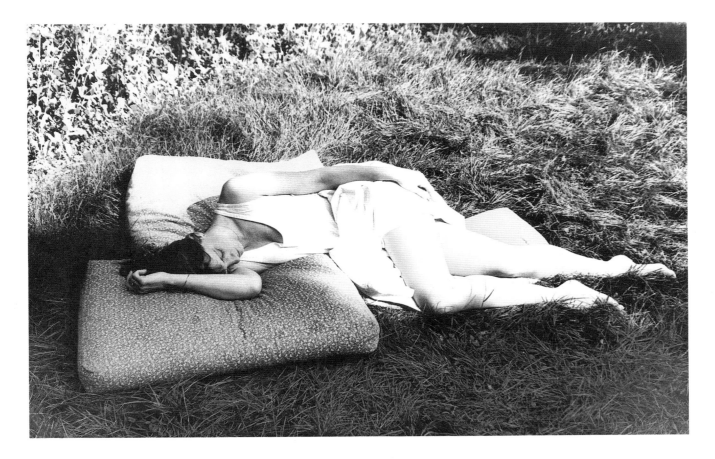

style and dress, and the Italian newspaper from which he is temporarily distracted, but also through the effect of strong sunlight defined by brilliant highlights and hard-edged shadows.

The location is in fact a doorway in Bath, in the west of England, and the model is not Italian - but the sunshine is real. The picture is an example of how photographic realism can give authenticity to a staged image. The subject was chosen for personal interest, not as a commissioned work, and at the time Hulme had no particular intention of adding colour to it. Later, however, when he was reviewing his pictures with the idea of handtinting selected images, it occurred to him that this was one which would work well with colour treatment.

Mark Hamilton has contrived a gentle, languid mood in his study of a female figure reclining in a garden setting (above). Again this is a seemingly casual moment, but Hamilton has paid careful attention to the details of form and texture which have been so beautifully enhanced by his handtinting methods. The smooth, pale tones of the figure are surrounded

Mark Hamilton's colour work creates a subtle sense of movement in this peaceful scene, where different hues and tints in the grass swirl around the fluid lines of the figure. The flowers make a vivid display although the delicacy of colour ensures that they form a natural background which does not intrude on the central subject.

Broad areas with colour tint, such as the cushions and the flesh tones, were masked off during the painting process to keep the contours distinct. The masking also helped Hamilton to remodel the forms where intense light had bleached out the detail, as in the legs and hand. The depth and volume in these areas are reinstated through the use of colour rather than tonal values.

# Handtinting Photographs

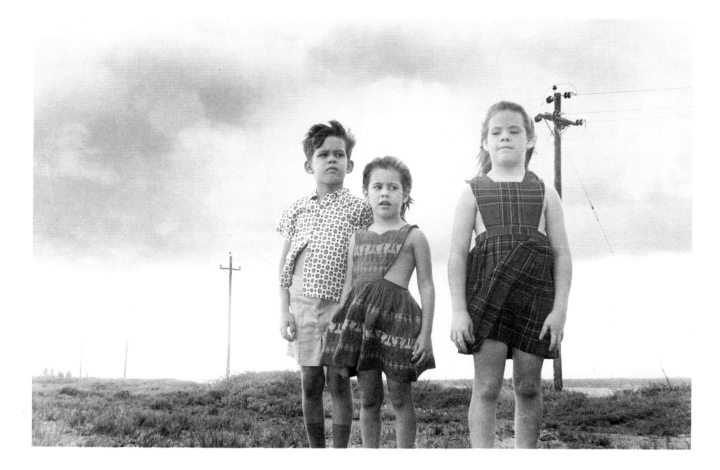

**Mark Hamilton**
This print was taken from an old monochrome negative then sepia-toned before Hamilton began to build up colour using water-based dyes. Areas of the sky near the horizon were bleached out to add drama to the background.

by a wealth of colour detail - in the border of flowers, the individual blades of grass, and the patterned cushions. Solid blocks of colour and pattern contrast nicely with irregular organic textures.

Similar design elements are included in Hamilton's colour treatment of a photograph of three children outlined against a heavy sky (above). Again there are formal pattern blocks contrasted with a natural background texture. In this picture Hamilton has developed the fabric patterns with a more intricate interpretation of colour detail, following meticulously the individual shapes described by the monochrome picture.

The sepia toning softens the contrasts but its warmth does not alleviate the generally bleak atmosphere of open landscape. In the same way, a heavy pink glow in the sky has more of a threatening than a comforting quality. The soft merging of colours in the sky resembles the flawless surface quality of airbrushing, but it is achieved by brush painting and using tissues to gently blend the still wet washes of colour.

The low-angle viewpoint creates a highly dramatic image and the picture is continuously intriguing because there is no clear identity to the location or the children, and no explanation of why they are there: no indication, either, of what it is outside the picture frame to the right that has secured the attention of the two smaller children. With their insubstantial garments catching the wind these three seem set up against the elements, as exposed as the slender telegraph poles behind them which describe the deep perspective view. It does not solve the mystery, but adds to the fascination, to discover that the boy on the left is Mark Hamilton. The original monochrome photograph was taken by his father, Bob Hamilton, and the adult Mark's careful handtinting gives new life to a long-cherished image.

Clint Eley has created a slightly surreal element in this print which produces the almost irresistible urge to turn the picture the other way up to see how it looks, and it works both ways, the sign of satisfactory balance in a composition. The colours are naturalistic, but in design terms form a precise contribution to the balanced effect. The blue clothing of the figure leads into a deeper tone of blue in the section of the umbrella framing the girl's head. This forms a solid central axis to the image, though slightly off-centre of the picture frame, from which the bright triangles of yellow, red and green fan out in a vivid halo.

Another level of surface interest comes from the texture and movement in the water, breaking up the reflection so that it passes from solid blocks of colour into a complex pattern of tonal values. Hard detail in the static edges of the riverbank give way to amorphous veils of light and colour in the disturbed reflection, anchored by a progression to sharper definition in the colour triangles. This forms a secondary diagonal axis across the picture which, combined with the central vertical, creates a pleasing symmetry though the visual elements of the composition are richly varied.

**Clint Eley**

The point of using handtinting rather than colour photography was to allow Eley complete freedom to brighten this image in any way he pleased and to bring in the brilliant artificiality of fairground colours which enhance the festive mood.

The dramatic tonal contrasts and curiously angled viewpoint of the shot are calculated risks. Dense shadows set off the dazzlingly high key of the colour work. The effect of radiant light is cleverly enhanced by diffused highlighting on the framework of the organ and pure golden tones reflected over the backs of the figures.

## Experiencing colour

In complete contrast, an upbeat mood with colours to match is supplied by Clint Eley's reflected figure framed upside down in the river edge by a large, loud umbrella (previous page). This forms an interesting comparison not only with the work of other handtinters but also with Eley's current use of handcolouring techniques and effects (see also pages 85, 100, 103, 110).

This is an early experimental work which Eley now regards as a very basic exercise in handtinting. The hard, bright colours seem entirely appropriate to the image, though Eley now favours a softer, more complex approach to surface detail. At the time when this piece was completed, he was trying out textures and colour values using the simplest materials. Apart from the colouring, however, this is a striking and witty composition with a vigorous charm. It illustrates the precept that usually only a good photograph is worth colour elaboration, which provides a way of further enhancing the image. The colour work is intended to flatter and not disguise the original quality of the shot.

A more recent, commissioned work shows a completely different approach to colour and the expert control of the medium that Eley has mastered through some years' experience. A lighthearted promotional image for a music company (left) vibrates with luminous graduated tints. The promotional theme aims to present the human face of a large corporation with its executives literally facing the music, but with tongue-in-cheek style. It takes, however, serious motive and concentration to succeed in pulling off an elaborate image of this kind. The insouciant mood of the double portrait derives from tightly professional discipline in the photographic and handtinting techniques.

## Portrait studies

Anyone interested in photography will at some time find themselves making a portrait of a friend or relative, and it is not unlikely that this shot will rank among the photographer's favourite pictures. An element of recognition and personal association are both standard responses to portraiture, even in the impartial viewer. If you do not know the subject, you might be reminded of someone you do know; you might appreciate the person's style or good looks, or make assumptions about their way of life. People in photographs offer a touchstone for one's own experience, sometimes by seeming to reciprocate the attention - the sense of 'watching me watching you' that comes from the subject looking directly into camera.

Two of these handtinted portraits have that slightly challenging look, but they are very different images in style and intent. Gerry Reilly's head and shoulders portrait (overleaf) is one of a couple of last minute black-and-white shots which he took for his own interest at the end of a day's shooting

## Handtinting Photographs

Gerry Reilly split-toned this image in selenium toner to develop the velvety blacks and warm greys. The colours were then applied by handtinting with dyes with Reilly working towards an overall effect of genuine but faded colour. This quality of slight 'ageing' of the image was assisted by absorption of the dyes, which penetrate the surface of the picture and lose all trace of brushmarks. Reilly feels there is less latitude in interpreting a figure subject than when handcolouring, say, a landscape image. He has obtained here a realistic effect with a powerful sense of mood.

on a commissioned job (his main line of work is advertising photography). This is obviously a posed shot - the model, apart from being very beautiful, has an elegant poise which speaks of familiarity with the camera's impersonal gaze and the lighting is carefully set up to create soft but intense contrasts of light and shade. Reilly's intention was to catch the atmospheric quality of a 1930s movie poster, hence the hat and the dramatic background shadows.

Adriene Veninger's study of *Ingrid* (right) is a total contrast in style and presentation of a portrait. The forms and colours are ethereal compared to the shadowy realism of the previous portrait. At first sight the image has an ancient quality recalling classical statuary, though the woman's face

also has a distinct modernity.

Ingrid is Veninger's sister, who works as an actress in Canada and the USA. This is one of series of portraits carried out as promotional images for her; they were later also printed as postcards. The classical references are deliberate, created by a collaboration of Veninger, Ingrid, and professional hair and make-up artists. Each portrait was given a different style and mood, mainly keeping to classical themes. The commercial context of this work is unusual for Veninger, who generally pursues her photographic interests as a personal investigation and rarely works on commission. However, the close family relationship involved here provides a naturally personal element to the work, and Veninger's special skills as a handtinter provide for Ingrid a unique interest to her folio of promotional pictures.

Another image with a distinctive mood and personality is Roderick Field's full-figure shot of a girl wearing a vivid green beret (overleaf). This is typical of Field's approach to using colour to highlight specific details of

**Adriene Veninger: Ingrid**
This is a high-toned image in which shadow areas gently frame the face and model subtle contours. The oil colours which Veninger uses for the handtinting provide a comparably delicate range of pastel tints, enhancing the textural interest of the image. The colour is also used to create discreet outlines to the figure - as on the left shoulder and the right side of the head - which add definition without exaggerating the pictorial depth.

## Handtinting Photographs

Roderick Field's usual method for handtinting, which he used in this image, is to print the monochrome image with the exposure time reduced by about 15 per cent, to allow for the added depth which handtinting will supply. He then works in transparent oil colours which give an intense colour effect without masking the monochrome detail.

a monochrome image, although he also likes to add colour by chemical toning where appropriate. His wife, Maria Field, frequently contributes her own expertise in handtinting to Field's photographic work.

This is, in effect, a full length portrait but the girl's pose, with her body bent forward and legs drawn up, forms a compact shape within the picture

area. The grainy texture of the print is given light washes of colour, except where the hair and beret form brilliant focal points. The rich green complements the soft greys of the monochrome range and is played off against the warm yellow lights applied to the hair and tiny earring detail.

It is an unconventional portrait that covers the subject's face, but there is a sense in which Mark Hamilton's close-up study (above) is as descriptive of his model as a more formal pose. In a curious way, the hands establish identity instead of the unseen face, and they are developed in some detail by the use of subtle flesh tints varying in warmth and density. The character of the face resides in the highlighted contour of cheek and jaw.

**Mark Hamilton**

The strength of this image lies in its tonal depth and design, and the colour work emphasizes the hard-edged divisions within the picture. The shapes are solid and very precisely drawn by the cold photographic monochrome except in the unfocused part of the background which together with the flat blue tint, throws the sharp contours of the figure into greater relief. Textures are also important to the image, particularly the clear linear pattern of the ribbed sweater.

**Housk Randall: Framed**

This picture was a self-assigned project by Housk which later became a poster image. The photographic original was a 12x16in (30x40cm) silver bromide print which was given sepia toning. The handtinting was done with watercolours painted on with brushes. Housk makes the colour decisions when confronted by the completed photographic print, considering the range of his palette in terms of the mood and subject. He describes his aim as 'to make pretty pictures which provide a bit more', drawing the viewer in by the surface attractiveness of the image, but contriving elements of unease which demand a gradually more complex response. His particular themes are the passage of time and the changing nature of things. He likes to contrast this with a sense of stillness in an image, which nonetheless contains a disconcerting ambiguity beneath the surface layers.

Housk's particular themes are the passage of time and the changing nature of things. He likes to contrast this with a sense of stillness in an image, which nonetheless contains a disconcerting ambiguity beneath the surface layers- an effect which is evident in this portrait.

# Alternative concepts

The geometry of picture-making is focused in images produced by Deborah Samuels and Housk Randall. Their separate approaches deal with the formalities of picture space in different ways and for different reasons, but each is in part a comment on the nature of art and the actuality of the photographic image.

Housk Randall's *Framed* (above) is a classic comment on the ambiguity of pictorial space and the visual image as something which is both seen into and seen through. Housk's father is a painter and sculptor, his mother an actress and dancer, a family background which seems almost directly illustrated in this complex portrait. The model's fluid elegance and elaborate mode of dress have an element of theatricality. The play on the framing device, the picture within a picture, makes reference to the illusionism which has been the province of painters for centuries and has been translated more recently into film and photography.

Housk is particularly interested in the painterly aspects of his craft. He

trained as a fine artist and then moved into a successful career in the music business. He took up photography as a relaxing pastime while recovering from illness but rapidly became fascinated by its potential and developed ways of incorporating the painting techniques he had previously learned. This has involved becoming expert in photographic technique and in uniquely personal ways of preparing his own colouring materials.

Deborah Samuel has taken the work of an artist friend as the basis for *Jayme's Geometry* (overleaf), a portrait with strong abstract qualities. Jayme Odgers works with photography and mixed media: Samuel created this image on the inspiration of the geometric elements which she found in

**Above**: Housk's original black and white photographic print.

**Left**: The same print after handtinting. Housk created the very different effects in this image by first treating the watercolour paper on which the print is developed. He mixed an emulsion of silver nitrate and gelatin and spread it on certain of the areas of the print. He then developed, washed and dried the image archivally, using a toner like selenium. Later he added colour using charcoal, pastels and watercolours to add the extra mood and painterly quality.

# Handtinting Photographs

**Deborah Samuel: Jayme's Geometry**

The staging of this photograph produced a monochrome print of heavy tonal contrast and subtle texture.

Samuels used a range of watercolour paints and dyes, selecting different colours from different brand makes to obtain the precise qualities required. The handtinting was extremely time-consuming: the depth and richness of the colour was built up by applying watercolour washes layer upon layer to strengthen and elaborate the image. The colouring cleverly enhances crisp textures in the hair and facial features, while in the background it vividly illuminates the soft-edged qualities of the triangular shapes.

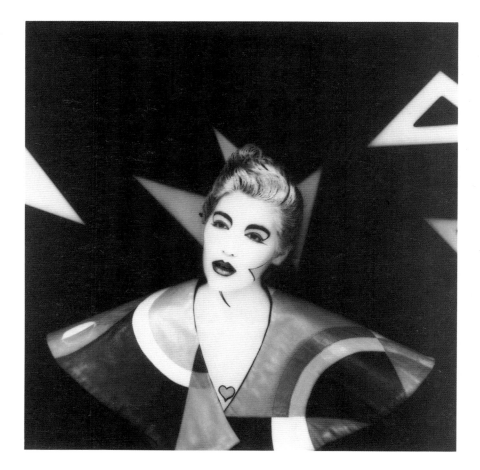

his work, though she stresses that this picture bears no direct reference to Odger's own style. This striking portrait is a project of personal interest, not a commissioned work, which was included in an exhibition of Samuel's pictures under the overall title 'The Spring Collection'.

The model's bold make-up and geometrically patterned cape were contrived as the centrepiece of the image. The background elements are simple instruments of geometric measurement - plastic set squares (triangles) which were sprayed with flat tone and either attached to the model's head or suspended from the ceiling to create the pictorial space.

# The body

The female nude has been a principal subject of art from the time when artists first began to create representative images. It has served symbolic

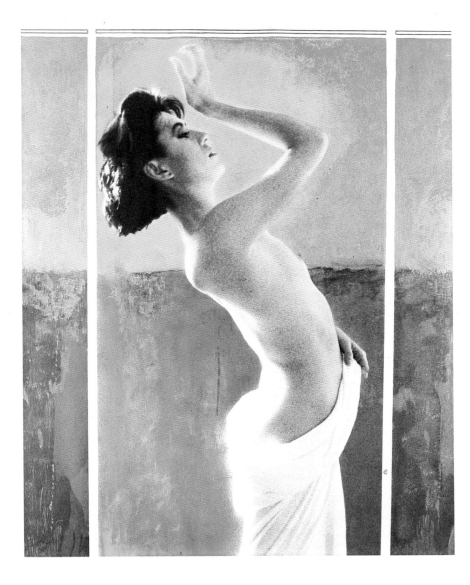

Adriene Veninger has borrowed from Mucha the idea of setting the figure within a panelled frame, and decorating the background with gold to halo the woman's head and enhance the lighting effect. Untypically, as Veninger normally develops surface colour and texture in the handtinting, she here incorporated some special techniques in printing the original image to obtain the particular qualities of light and the controlled tonal range. The gold, however, is a surface treatment, painted on with gouache. Loose brushwork contributes a shimmering texture to these areas of gilding.

The discreet brilliance of the overall effect, apart from the actual shine of the gold paint, comes from almost silhouetting the figure while illuminating the contour with intense bands of reflective light. The silhouetted impression, however, depends also upon the colour balance and the strong outlines of head and body. There is considerable tonal detail within the form describing the skin tones and musculature of the shoulder. The model was a dancer, as is shown in the fluid body tensions of the pose.

and aesthetic purposes, and has been endlessly interpreted in a variety of contexts and through the entire range of artistic styles. Almost inevitably, when an artist creates a new image of the female figure, it becomes resonant with echoes of past patterns.

Adriene Veninger has treated her study of a three-quarter length portrait of a draped figure (above) as a deliberate homage to a particular artist, Mucha, whose gilded images in the Art Nouveau style have gained an enduring identity in the iconography of female form. Mucha's elaborately decorative representations have for some time been popular poster subjects, and many people would recognize a reference to his work in Veninger's

figure, even without knowing the artist's name.

A very different approach to a similarly classical pose calls up references to artistic antecedents from Goya through Ingres to Manet. Andrew Sanderson's figure study entitled *Nicola* (below) might come from the painting academies of the eighteenth or nineteenth centuries, except that there is a simultaneous impression of distinct modernity. It is not easy to define precisely how this delicately accented study comes across as so significantly contemporary, but it is perhaps to do with the economy of visual values which Sanderson has achieved. The tonal range is perfectly balanced in the lighting and exposure of the photographic study; the subtle transitions through a limited colour range provided by the handtinting enhance the coherence of the image.

## Telling details

Fashion photography is a much younger artform than life-studies from the nude, but one which has already established its own traditions and precedents so photographers have to work hard to produce an eye-catching, new approach to their subjects. Helen Z was commissioned to handtint selected pictures from a professional photographer's portfolio to produce images which would stand out in this crowded field of photographic work, giving an extra dimension to the visual style on display in the presentation.

**Andrew Sanderson: Nicola**

The hard greys of the photographic tonal key are replaced by rich brown shadows and warm lights. Sanderson has brushed in glazes and veils of translucent colour which gradually increase the modelling of the forms and add fleshly reality to the figure. The flawless skin texture and fluid curves of the body come completely to life in an atmospheric setting simply contrived by the gentle drapery. A particularly beautiful touch is the streak of golden hair flowing over the dark mass of the head and tumbling across the smooth line of the shoulders

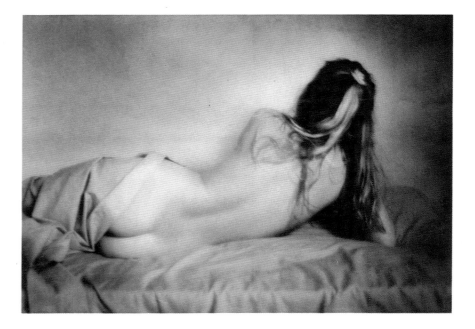

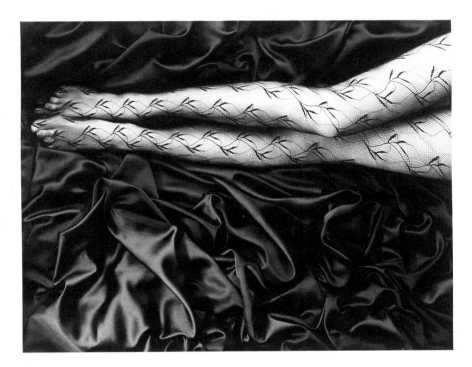

Helen Z has produced the depth of tone by immersing the print in a bath of colour toner. She first masked out the shape of the legs, so that the background fabric was fully coloured while the legs retained the neutrality of the photographic greys. To link these two elements of the image, she then removed the mask and used handtinting techniques to blend the purple tone into the contours of legs and feet. This created areas of subtly reflected colour and produced a wholly integrated merger of the original print and the colour treatment.

With or without added colour, the example shown here (above) is a particularly striking image, evoking both current fashion, in the boldly patterned stockings, and timeless elegance in the luxurious satin drapery used to create the background tones. It has also the peculiar anonymity often required of fashion shots, which enables the viewer to translate the image in terms of her own physique, personality and clothing style. The disembodied limbs also supply that essential hint of wicked seduction which advertisers rely upon to stimulate the potential market for all manner of products, and which magazine editors offer to their readers as an unspoken promise of some sophisticated enjoyment from the lifestyle they promote.

Helen Z has devised an equally sophisticated colour treatment which literally just tints the black-and-white picture, but with a colour rich in associations, a resonant deep purple which is modulated by the monochrome range throughout the image, producing undertones of indigo and midnight blue. Purple is the colour of wealth, because at one time purple dyes were rare and expensive, and has also been associated with political power and even royal status since the days of the first great empires of the world. This, of course, is not a message consciously conveyed by the choice of this colour, but it is in the subliminal heritage of western culture and something which we may draw upon without knowing.

SPIRIT

*Spirit of ENGLAND*

JERROLD NORTHROP MOORE

EDWARD E

JERROL

ISBN 0-434-47541-6

# The Media

Juliette Soester handtinted this Heinemann book jacket by subtly building up the colour and allowing the paint layers to dry before reworking.

A dictionary definition of the word 'media' defines this as an informal reference to mass media, that is, the sources of published and broadcast information. It covers, however, a massive and varied range of contexts, a melting-pot of style and image-presentation which has enormous influence on our lives. Advertising has become a focal point of the 'media' because it is available through many outlets and is designed to be of personal significance to individuals. It is also the most eclectic resource, picking up on trends from movies, television and publishing and re-packaging them to be sent out again via the same channels of information. Advertising is specifically designed to make you look, to make you want, and to make you buy. But it is not only this element of the media that has such an effect; it may simply be the most blatant in allowing its aims and methods to be seen.

Many of the handtinted images already shown in this book are media-based, particularly in the context of advertising. In this section, other areas of this broad category of work are examined, and the concepts of advertising and promotional work are analysed more closely.

# Publishing

It is almost an axiom of the book trade that you can judge a book by its cover, in that the jacket is the first element to attract a potential buyer and is required to advertise the contents of the book to the right market. There have been and will be notable exceptions to this rule, especially where a recognized style element is an important aspect of the book's appeal, but in general terms it is the function of a book cover to be both attractive and unambiguously informative.

The jacket design for *Spirit of England* (previous pages ), published by Heinemann in the UK, targets its mood and subject very precisely. This is a serious study of composer Edward Elgar and the world in which he lived. The cover is designed to combine the two main themes unambiguously, with a portrait of the composer inset over a typical English landscape. The low-key colouring presents a gentle, lyrical mood appropriate to the musical theme. This is mainly expressed in a warm brown monotone casting soft light over the landscape. Juliette Soester was commissioned to colour the photograph of Elgar which forms the focal point of the design.

Although this was a relatively simple job of handtinting, Soester was particularly gratified by the commission, as she loves Elgar's music. She gave careful thought to the original - a tiny black-and-white print - before starting the colour work. She gave it a sepia tone which not only softens the tonal range but also sets a period mood.

In the final jacket design, the portrait is both integrated with and distinct from the background landscape, the variation of warm brown tones giving depth and interest to the overall impression. The typographic elements are cleanly designed and evenly weighted to read easily over the picture surface.

# Music

Rock and pop imagery has always been deliberately colourful - colour and light are part of the excitement of a live performance. Clint Eley has vividly celebrated this aspect in a fast-moving image taken at a rehearsal session with the band Level 42 (above right). The action of the drummer becomes a multiple image integrated with the flashes of light coming off the shining instruments. There is just enough sharpness in the linear elements of the

picture - the microphone and drum stands - to act as a reference framework across which the sense of movement dances throughout the image. It is not surprising that Eley particularly liked the shot and chose to give it colour treatment purely for his own pleasure.

If you had seen this in another context, very likely you would not realize it is a handtinted photograph, so expertly has Eley applied the shimmering yellows, blues and reds. The vibrant atmosphere of live music is everywhere conveyed.

Bob Carlos Clarke also took a one-off opportunity to develop a fascinating image with his highly subtle brand of handtinting. *The Dark Sisters* (overleaf) were models styled for a photo session to produce a cover image for an Ozzie Osborne album. At the end of the session Carlos Clarke snatched a couple of black-and-white shots of the sisters while they were still in costume. This photograph was printed at 20 x 24inches (50 x 60cm) and first coloured with chemical toners. Carlos Clarke then masked selected

**Clint Eley: Level 42**
Every nuance of the lighting effects in this image, from the needle-sharp reflections travelling into the surrounding darkness to the central soft diffusion of tones, is enhanced by the balance of colours which he has woven throughout the image.

# Handtinting Photographs

**Bob Carlos Clarke: The Dark Sisters**
After darkroom toning, this image was subtly handtinted with an airbrush to create a sophisticated and disturbing effect.

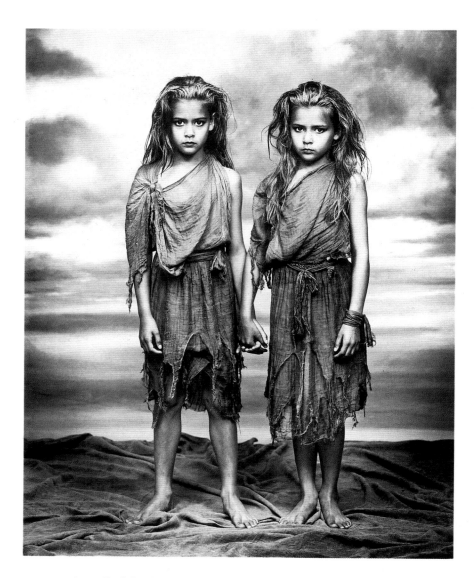

areas and applied further colour with an airbrush.

The original image has considerable beauty and power, coming from both the model and setting which are combined to produce a weirdly primitive effect. But this is also a very sophisticated work, and the colouring is intended to enhance the picture subtly, not to make it colourful but to provide a distinct difference between the final result after tinting and the initial, more basic tonal qualities of the black-and-white print. That result is a unique image of disturbing intensity and resonant tonal range.

Bright colour is a deliberate feature of an album cover handtinted by Helen Z, showing actress Joanne Whalley in her early role as a fifties-style singer (above right and overleaf). The black-and-white version shows the

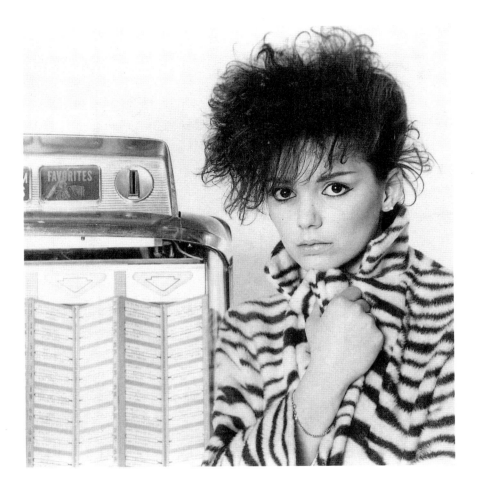

strong sense of design applied to setting up the image, with the two blocks of pattern formed by the juke-box directory on one side and the singer in her tiger-striped jacket on the other. This was Helen Z's first commissioned work in handtinting and she was given a tight brief to develop the period mood with strong colour and a precisely figurative interpretation. The point of a handtinting exercise such as this is not to produce total authenticity, which could be done with careful propping and colour photography, but to develop an overall mood and style which conveys the desired effect of time and place.

# Product

Almost all media work is about product, whether this is a book, a rock band or a brand-name consumer item. This is an increasingly important concept which needs to be clearly identified and targeted within a given context.

# Handtinting Photographs

**Helen Z: Joanne Whalley record sleeve**
Helen Z worked on the juke-box with brushes to lay in the candy-coloured tints of the record cards and the lit signs on the chromework. She then masked off the area of the jacket and washed in the intense blue with cotton wool swabs, building up the depth of colour gradually. The face and hands again required careful brushwork, particularly the finely drawn details such as the colour in lips and eyes.

Sometimes this involves focusing the actual product as clearly as possible. At other times it is a matter of creating the mood and style of the product image, or developing a range of oblique but pointed references which will call up the right associations in the viewer's mind.

The food and drink markets cover an enormous and varied range of products, from junk food in brash packaging to discreet delicacies for the connoisseur. A classic wine shot representing the upper end of the market (opposite) was presented to Helen Z as a handtinting commission. Photographer Tim Hazael had already sepia-toned the image. It was left mainly to Helen's discretion how and where to interpret the colour references, except that it was specified that the wine should have a rich, warm colour.

Helen preserved a careful sense of the balance of the image and avoided flattening out the picture space by fading her colours across each area to vary the depth of tone. At the top of the picture, for example, where the frame cuts off the shape of the glass, she did not bring the red right out

to the edges but left the dark sepia of the original print. This ability to judge how not to 'overdo' the colour balance is an important skill in handtinting.

A very complex web of image and association has been woven around the twentieth-century icon of the automobile (overleaf). The highly reflective qualities of chrome and glossy paintwork are fully exploited in sales and advertising images to suggest the sophistication and power of the product. Mark Hamilton's exploration of this iconography goes even beyond the normal complex visuals of automobile art, allowing the layered pattern of reflections to cut across the forms, producing an image of rich contrast.

This is the kind of image much taken up by airbrush artists and which

Helen Z infused the wine with a heavy dark red tint and, introducing the principle of opposite colours, decided to develop the marble texture with a deep green. She applied this with brushes to follow the complex tonal range of the marble veining. For pictorial reasons it worked well to merge this into subtle red tones in foreground and background, bringing added focus to the edge of the marbled moulding on the same visual level as the detail in wine glass and bottle. The final touch was the realistic pale brown tint on the cork.

**Mark Hamilton**

The colour is applied by a methodical and patient process of masking off detail areas for working. There are many subtle nuances in the colour quality which read as a coherent surface but which contain many delicate shifts of colour balance. The green passes through a range of tints from a strong yellow-green on the upper surfaces of the paintwork through a more gentle blue-green in the moulded curve around the headlamp, to a dash of brilliant emerald in the sidelight area which leads the eye to the complex texture of the chromework reflections.

has over the years become become a self-referential genre. Hamilton matches the sleek interpretative style of airbrush work, but this is not a tool he uses for handtinting, usually preferring hand-painted brushwork.

Ground level is represented by a light yellow bordering on neutral tone. The background is touched with a cold, pale blue associated with sky tones, although the actual background plane is formed by a corrugated panel. Between these two elements the blunt nose of the cadillac is thrust out towards the viewer. The reflections take in everything in the vicinity, from other parts of the car reflecting into the chromework, to the distorted vision of the surrounding street buildings which is wrapped around the curve of the bumper. Dazzle from the chrome detail is echoed in the brilliant yellow-green flash of light splashed onto the paintwork above.

142

Apart from direct media advertising, large companies also put out a range of promotional products often aimed at underpinning rather than necessarily increasing their market share.

An annual calendar sometimes becomes a media event in itself, like the famous Pirelli calendars which set new standards of promotional style. More commonly this element of a promotion performs the function of a quieter emphasis regularly applied to a particular product image. Clint Eley's work in this field is represented here (below) by a selection from a series of pictures which tangentially illustrate a brand name product (never openly on display in the photographs) by means of an established colour reference - black and gold. This has already been firmly associated with the style and quality of the product through previous advertising campaigns.

**Clint Eley:**
**John Player Special advertisement**
This commission involved shooting the photographs in strongly contrasted black-and-white, then adding discreet touches of gold in the form of handtinted yellow tones.

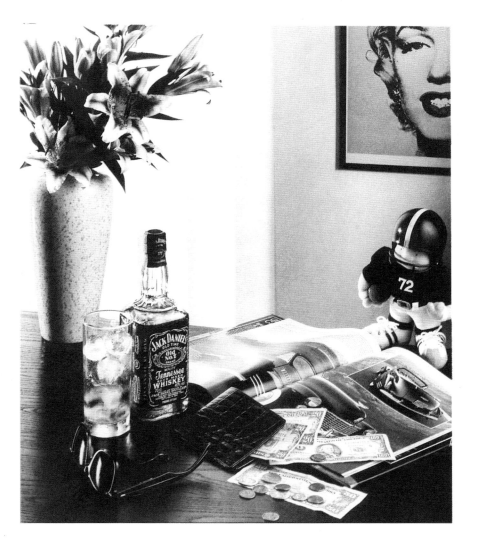

The actual brand name does not appear (one picture does include the product logo), though it is consistently repeated in the copylines which accompany the pictures on the calendar pages. Mostly, the reference is to be inferred from the strictly visual cues of colour and styling in the photographs.

## Advertising

The more direct form of advertising consists of presenting unambiguously the product, with its name and company name, and the image of a lifestyle or working context to be associated with it. Once again, the automobile market leads the field, often providing among the most memorable magazine and television advertising, not to mention the lavish sales brochures designed to launch a new product or stimulate new interest in the range of cars.

**Clint Eley: Mazda advertisements (right and opposite)**
The advertisements were shot in black-and-white for handtinting, the cars photographed separately in colour.

Because this is an expensive market allowing high-budget advertising, the prestige value of full-colour photography has been fully exploited over many years. More recently, manufacturers have turned to a different forms of presentation geared to various aspects of eighties style, and the resulting images have included handtinted photography of the products. Clint Eley's promotional shots for the Mazda 323 and 626 models involved quite an elaborate chain of processing to produce a stylishly different package.

The background locations were shot in black-and-white before handtinting: using precisely the same angle and depth of view, the cars were shot separately in colour. For each individual picture, the two elements were married by computer processing. The colour transparencies of the cars provide the sharp realism typically required in automobile advertising; the handtinted monochromes create an elegant, semi-nostalgic mood framing the cars' modernity; the advanced technology of computer scanning makes the montage appear absolutely seamless.

# Handtinting Photographs

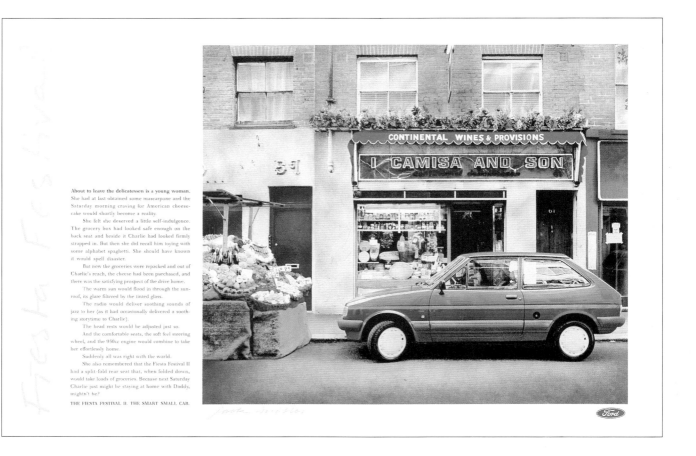

*Inside the image, text reads:*

CONTINENTAL WINES & PROVISIONS

I CAMISA AND SON

About to leave the delicatessen is a young woman.
She had at last obtained some mascarpone and the
Saturday morning craving for American cheese-
cake would shortly become a reality.

She felt she deserved a little self-indulgence.
The grocery box had looked safe enough on the
back seat and beside it Charlie had looked firmly
strapped in. But then she did recall him toying with
some alphabet spaghetti. She should have known
it would spell disaster.

But now the groceries were repacked and out of
Charlie's reach, the cheese had been purchased, and
there was the satisfying prospect of the drive home.

The warm sun would flood in through the sun-
roof, its glare filtered by the tinted glass.

The radio would deliver soothing sounds of
jazz to her (as it had occasionally delivered a sooth-
ing storytime to Charlie).

The head rests would be adjusted just so.

And the comfortable seats, the soft feel steering
wheel, and the 950cc engine would combine to take
her effortlessly home.

Suddenly all was right with the world.

She also remembered that the Fiesta Festival II
had a split-fold rear seat that, when folded down,
would take loads of groceries. Because next Saturday
Charlie just might be staying at home with Daddy,
mightn't he?

THE FIESTA FESTIVAL II. THE SMART SMALL CAR.

Ford

## Fiesta Festival II

The complex process of masking and spraying in airbrush work enabled the artist of this advertisement to isolate intricate details such as that in the shop window and vegetable stall, as well as the clean shapes of lettering and other more graphic components. The car itself must obviously appear realistic and sufficiently detailed to establish the product identity.

The impact of a new visual slant to an established convention of presentation is also displayed in a 1988 ad for Ford promoting their Fiesta Festival II, 'the smart small car' (above). The ad agency handling the account, Ogilvy and Mather, wanted something different from the many glorious full-colour photographs already a standard item of production values in this field of advertising. They chose to use the established style and reputation of artist Jack Miller as the 'different' element. He was commissioned to add colour to the picture, using his highly developed airbrushing skills. Artist and art director attended the photographic shoots to have full visual control over the image they were seeking.

The result is an immensely detailed colour study, yet with a subtle individuality which clearly marks its difference from the style of straightforward colour photography. The 'story' which goes with the image, and which is developed in the accompanying text copy, refers to a woman on a shopping trip to the delicatessen accompanied by her young

child. The image of the car is that it is smart and economical, but as individualistic as the owner who has a natural taste for good foods. However, this is also presented as a car that is practical and becomes accommodated to the owner's driving needs. Other hints are provided about the car owner's lifestyle which suggest that she is busy, possibly a working mother, young but not so young as to be inexperienced in the good things of life, and with a partner sharing her tastes and responsibility for a chosen way of life. The ad is precisely targeted on one aspect of the potential market, and was one of a series of four which developed other themes within a similar market range.

## Image-building

Two sharply designed images with a precise sense of current mood ran in *Airport* magazine ('the magazine for frequent travellers') in the summer of

**Teddys advertisement**

Colouring the teddy bear alone enhanced the comparison between the soft and hard aspects of the image. A transparency was made from the monochrome print which Tim Platt handtinted to lay in the warm yellow. The transparency was then processed for four-colour reproduction which brought out barely perceptible hints of viridian and magenta in the blacks and greys, maintaining the dramatic tonal contrast but giving it a warmer feel.

1988. The company name is Teddys Ltd, which proves largely self-explanatory. The pictures show a ruthless-looking young executive in a jet-passenger seat cradling in his arms a large and extremely benign-looking teddy bear. In one ad, the businessman holds the bear a little self-consciously: the copy line reads 'Even corporate raiders have their little weaknesses'. In the one on the previous page the relaxed executive has gone to sleep with his cheek resting on the teddy's head, and the ad asks 'Are you man enough to carry this off?'.

These two ads present a clever product image which involves a network of linked themes and references. To start with, the company is based at London's Gatwick Airport, hence the placing of the ads in a travel magazine and the specific target image of the jet-setting businessman. The executive style was designed to pick up on the success of the then recently-released movie, Wall Street, and refers to the character in the film played by Michael Douglas, a no-holds-barred wheeler-dealer who reckons greed to be a motive needing no apology. The model for the ad bears a facial resemblance to the actor and his hair and clothes are styled in the manner of the movie character.

The visual play is between the hardness of this tough but sleekly attractive executive and the rounded, furry bear who has surprisingly become his travelling companion. In one ad the extended copylines focus on the availability of Teddys' product for the traveller pushed for time; the second, more relaxed image promotes the mail order side of the campaign (a useful service not only for those not quite man enough to share an aeroplane seat with a cuddly toy). It is made plain, but not over-stressed, that the teddy bear is bought as a gift and not really as a comforter for a tired businessman.

This broadly is the theme of the campaign concept. Further complex strands are woven together in the style of presentation. Immediate visual impact is an obvious goal, to interest the reader, make him (or her) stop on turning the page long enough to take time to read the copy. The magazine is printed with lots of colour advertising and editorial illustration. Art director of the Teddys' account Marek Grabowski realized that a primarily monochrome image could stand out powerfully against the general style of the magazine. He also considered that as advertising for toys often employs garish colour and relatively simple concepts, particularly when geared towards attracting a child's attention directly, this was an opportunity to

tdk. out of the home into the office.

tdk. number one in audio tape. major force in videotape. now our complete range of 5¼ and 3½ inch floppy disks brings the same exacting standards of data storage to your desktop. for modern computers everywhere. for availability ring 01-200 0200.

**TDK advertisement**
The very black-and-white description of the figures is allowed to speak for itself against a cold blue background which underlines the impersonality of the setting. The image required very careful attention to production values in reproduction. The tonalities of the photograph are critical, as was the colour value of the precise shade of blue.

produce a more sophisticated image unusual in this market.

Grabowski had previously seen the work of photographer Tim Platt and was impressed by the photographic discipline of his black-and-white images. Colour photography, as Grabowski says, is a more forgiving medium and can cover up visual problems, whereas monochrome demands a starker, more economical presentation. He had seen in Platt's work the visual impact lighting, but also a sense of fun just right for the Teddys'

# Handtinting Photographs

**Helen Z:**
**Epson Computers advertisement**
**(above and opposite)**
For this image  the warm atmosphere of the print was carried through in the yellow-brown colouring of the dog, set against colder background tints of blue and magenta. These two hues, which are in fact the company colours, were also delicately applied to the pencil and sharpener in the printout picture and the green tints in the scroll of paper were intensified. Helen Z  masked off individual areas while she applied the separate colour treatments.

concept.  The result is an image with full impact in its own right and in context which inevitably draws attention. The clever targeting of the campaign has been borne out by the success of the two ads.

Similar principles are at work in an ad for TDK, 'specialists in data storage'. Here again there is a specific target market, not an appeal to the general consumer: the advertising image has been tailored to the product context and also derives from the individual style of the photographer/ handtinter. But by contrast with the movie reference in the Teddys' ad, a deliberate decision was taken to avoid tying the product image to any identifiable current fashion. Newton and Godin, the agency responsible for this TDK ad and two others in the same series, preferred instead to create a highly stylized context interpreting the brand image. The overall concept was of a 'real/not-real' effect which would convey the highly technical, state-of-the-art condition of the product and present an all-encompassing lifestyle as the background to this targeted message.

The result is a bold image appropriate to late eighties style but also

conveying a futuristic element. The two women are styled with identical hair and make-up and subtle variations of a 'uniform' dress. They become, as described by Richard Carter of Newton and Godin, 'icons of modernity' - real women, not robots, but of a kind you will not meet among the data storage facilities. They are an impersonal human force in the overall image, but at the same time the dark gaze of the seated model addresses the viewer very directly. This hint of ambiguity parallels the sales message of a product which is of an exceptionally high standard yet is readily available to the discerning buyer.

The handtinted photograph was produced by Bob Carlos Clarke, a specialist in this field. His work was known to the agency and it was felt that the technique of handtinting on monochrome perfectly conveyed the unreal quality required for this particular image. The technological aspect is

**Helen Z**
The photographer split-toned both images with selenium toner before passing them to Helen Z for hand-colouring. The split-toning provides the rich bronzed colour of the darker tones and a light greenish tinge to pale areas.

represented in the sharpness and high contrast of the photograph, as well through the style of the models, the props and the uncluttered staging. The result is a picture of startlingly direct impact, which was run with only brief copylines providing the company name, a brief description of the products (stressing market leadership and high manufacturing standards) and a contact number for further information.

Two advertising photographs, taken by Rob Brimson and handtinted by Helen Z, work in a similar specialist market to that targeted by the TDK image, but the general theme of the campaign is deliberately personalized, emphasizing the time-saving efficiency of the promoted products. Both were devised by agency Stuart and Knight for Epson Computers, with Roger Ward the art director. In one a sturdy, probably well-meaning bulldog (an animate bulldog clip) wreaks havoc on a data-storage system in which papers are filed. In the second, an anonymous clerical worker desperately sharpens pencils while surrounded by a sea of unravelling computer paper . The ads are selling, respectively, portable computer data-storage systems and compact but speedy computer printers. Both pictures are designed to illustrate the potential nightmare of being unprepared for a specific task, a situation which the offered product can entirely resolve. The slightly surreal quality of the images is enhanced by the not-quite-real effect of the toning and handtinting applied to the photographs. The photographer split-toned both images with selenium toner before passing them to Helen Z for hand-colouring. The split-toning provides the rich bronzed colour of the darker tones and a light greenish tinge to pale areas. Helen masked off individual areas while she applied the separate colour treatments. The consistency of the photographic style and colouring implies the coherence of the corporate image while differently illustrating the range of their products and services.

## The moving image

Handtinting is not confined to the one-off photographic image and despite the continuing development of new computer animation programs, there are still artists prepared to enter upon a time-consuming and laborious project in order to obtain a 'hand-painted' quality on film. Examples are shown here in clips from a television ad and a rock video which use different techniques of colouring to achieve specific aims in the finished images.

**Giblets**
A still from the video **'I Call Your Name'** by Johnny Clegg and his band Savuka.

These serve to represent the technical and visual possibilities of the medium but cannot, through still images, convey the depth of the added colour. You need to apply to these frozen frames an imaginative projection of the continuous movement of a film cycle which animates the colour qualities as well as, and sometimes independently from, the pictorial content.

A very direct hand-painting technique was applied to colouring a video for Johnny Clegg and his band Savuka, *'I Call Your Name'* . This was produced by Giblets, a film production team of three directors and one editor who have up to now specialized in promos and pop videos. Mike Sumpter of Giblets explained that the idea behind the Johnny Clegg video was a reaction to a trend in recent work of this kind for making use of the

Da Vinci computerized colouring system. Giblets preferred the visual potential of actually handcolouring the film frames, giving a more organic and variable colour quality that seemed to match the band's energy and the rhythmic complexity of their music.

The film was shot in monochrome on 16mm and then blown up to 35mm. The film frames at 35mm are quite small, and the team of about twenty people who worked on the hand-painting over about seven days had to use magnifying glasses and very fine brushes to apply the colour. A copy of the film was cut up and distributed among the freelance artists, then rejoined when the work was complete. The basic monochrome was preserved and colours applied to the band members, their clothing and instruments, bringing them out from the black-and-white background of the film's locations.

Mike Sumpter points out that the working method does not allow such delicacy and subtlety of colour detail as can be applied to a one-off still photograph. The effect is less sophisticated, but compensates with a crudely vibrant energy and a shimmering colour effect in the moving image which derives from tiny changes of tone, texture and emphasis caused by each frame being individually coloured. Sumpter feels this is an exciting aspect of the work, in that colours can be deliberately changed from one frame to the next, enlivening the action and even capable of giving a magical or surreal quality to the imagery. Hand-painting has rarely been applied to film since the early days of silent movies, when it was the only available technique for providing colour. Sumpter believes that it has great potential for advertising or feature work, but regretfully admits that the time-consuming and labour-intensive aspects of the technique would normally prove prohibitively expensive on a grand scale.

A very different approach is evident in the 'Scribbles' television ad (opposite) commissioned by Horner Collins and Kirvan for Berol, makers of a range of writing and drawing pens. This too, however, was designed to have a 'hand-done' quality imitating the loose vigour of a drawing made with coloured pens. The colour work has a more precise and graphic quality than that of the Giblets' video, but an equal energy and individual style. The film background is shot in natural though slightly muted colour, the hand-drawn scribbles applied with vividly artificial colour. Brian Loftus was the film director responsible for the live action; Pete Bishop and Mark Kitchen-Smith of Film Garage devised the colour animation.

**Berol 'Scribbles' advertisement**

The scribbles, drawn in heavy pencil, were designed to fit the live action very precisely. The pencil scribbles were transferred to the film by a process of burning the drawn images into the film emulsion, producing black mattes forming 'windows' into which the artificial colour was inserted. The animation also involved improvising a fully rendered pen, which appeared to 'draw' the scribbles, since there was no way of animating a real pen in such a complex sequence.

The basic concept of the ad is of a young man walking down an ordinary street, while an animated Berol pen flashes in to scribble vivid colour values across moving elements such as passing figures and cars, and

finally gives the young man himself a bright new look to his clothes and sketches him in a shock of electric blue hair. There are two levels of movement, in the base film and in the colour animation, and the whole sequence has a lighthearted, immediate style which is attractive and memorable.

Different ways of making this happen on film were tried. The method which produced the preferred result is a relatively old-fashioned system of drawing every stage of the animation by hand. Computerized coloured systems produce a similar effect more quickly, but produce what Pete Bishop described as 'a neon line that tends to sit on the film action'. To give the colour animation a more natural and integrated quality, a set of drawings was produced following the movements through every frame of the film action - a process known as rotoscoping. Because the inserted colours were so accurately registered to the film action, the final result is completely integrated and the effect extremely lively. A television ad has to be designed to bear repeated viewing, and this award-winning example has a continual fascination every time.

# Acknowledgements
# Index

# Acknowledgements

Amanuensis would like to thank Annie Colbeck whose pictures inspired the idea of compiling a book on handtinting photographs. Also The Burton Holmes Organization for permission to use the pictures on pages 6-7, 13, 15 and 16; and the Trustees of the Science Museum, London for the picture on page 9.

# Index